SUPER
iam8bit

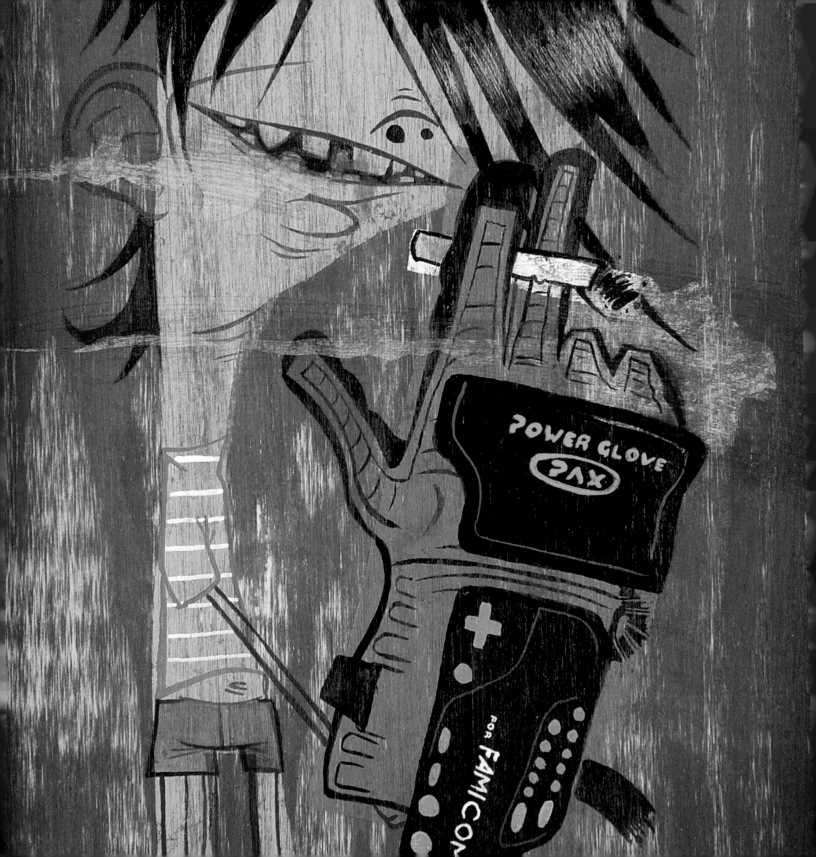

SUPER
iam8bit

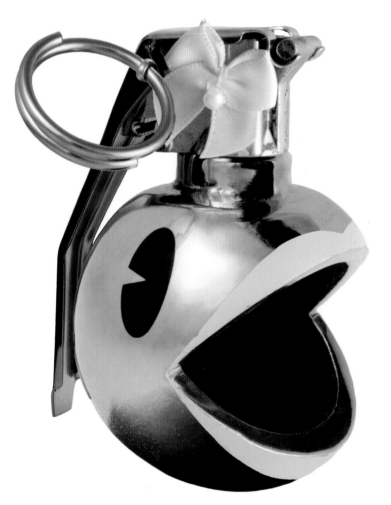

MORE ART INSPIRED BY CLASSIC VIDEO GAMES OF THE '80s

BY

Jon M. Gibson

Amanda White

Taylor Harrington

Nick Ahrens

FOREWORD BY

Kevin Pereira

iam8bit

 PLASTIC HIGHWAY

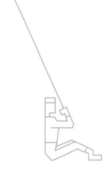

ISBN 13: 978-1-4507-7933-3

Manufactured in the United States.

Designed by **Hexanine** (hexanine.com).

Photography by **Love Ablan** (loveablan.com).

Distributed in United States and Canada by
SCB DISTRIBUTORS
15608 South New Century Dr.
Gardena, CA 90248

10 9 8 7 6 5 4 3 2 1

Co-Published by:

iam8bit Productions
2147 W. Sunset Blvd.
Los Angeles, CA 90026
iam8bit.com

Plastic Highway
1914 W. Montrose Ave. #3
Chicago IL 60613
plastichighway.com

2000

CARLOS RAMOS
Power Love
acrylic on wood — 10 x 20 inches
inspiration: **Nintendo Entertainment System**

3000
PETER GRONQUIST
Untitled
mixed media grenade — 2.5 x 3.5 x 2.5 inches
inspiration: **Ms. Pac-Man** (arcade)

6000
YUTA ONODA
Wish Upon a Star
mixed media — 24 x 16 inches
inspiration: **Super Mario Bros.** (NES)

12000
JORGE R. GUTIERREZ
My name is Mario. You killed my brother.
Prepare to die!
acrylic on wood — 18 x 14 inches
inspiration: **Super Mario Bros. series**

15000
YOSUKE UENO
Beginning the New Adventure
acrylic on canvas — 15.75 x 15.75 inches
inspiration: **Super Mario Bros.** (Famicom)

To friends,
with whom awesome collaborations happen...

...and to past experiences,
without which we wouldn't be as whole.

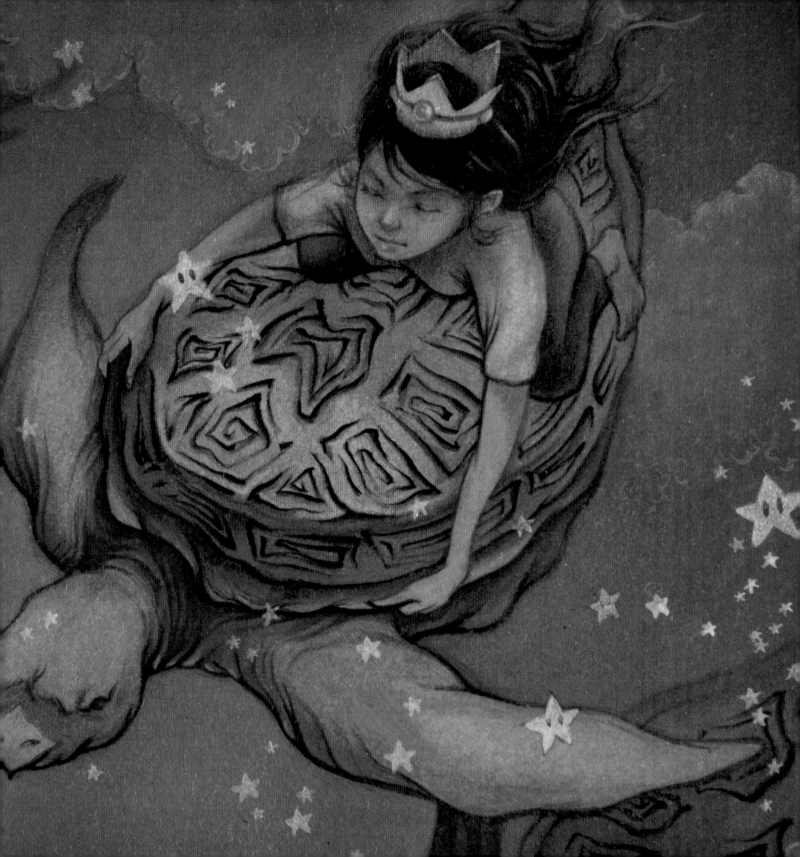

ACKNOWLEDGEMENTS

Abbie Heppe, Adam Sessler, Alan E. Minarik, Alan Miller, Alan, Keela, Grayson, Shay & Charley Harrington, Albert Yarusso, Aled Lewis, Alex Lowery, Alison Montgomery, Amanda Visell, Amy Skilling, Andrew Reiner, Andrew Schnorr, Andy Hamilton, Andy McNamara, Angie Mavrow, Beau Basse, Ben Zhu, Bernadette Binah Ortiz, Bill & Lance from Contra, Bob and Janet Lee, Bob Whitehead, Brad Winters, Brian Ashcraft, Brian Crecente, Brian Midkiff, Brian Rubin, Brian Singer, C-Bake, Casey Liddicoat, Chad Concelmo, Chad Schultz, Chris Baker, Chris Birch, Chris Carle, Chris Charla, Chris Kramer, Chris McD, Christopher Grant, Cliff Spohn, Craig Sinel, Dan Hsu, Dan Murray, Daniel Franzese, Dave Crosland, Dave Pava, David Crane, Derek Puleston, Ed Cunningham, Edmund Sims, Emilie Golub, Emily Johnson, Emily Lapetino, Emma Cunningham, Eric Kurland, Eric Monacelli, Fenton Bailey, Gabe Swarr, Gavin Purcell, Geoff Keighley, George Opperman, Gordon Bellamy, Grant Hollis, Greg Essig, Greg Rice, Harvey Dent, Hayden Walling, Ian Santer, Illya Quinteros, Inga Hamilton, Jack Pattillo, Jaime Rivadeneira, James St. James, James Stevenson, Jason Adam, Jason Torchinsky, Jeff Balis, Jeff Cork, Jensen Karp, Jeremy Hoffman, Jerinne Neils, Jessica Villarreal, Jim Mahfood, Jim Rugg, Jon Salmon, Jon Slusser, Jonathan Drake, Joveth Gonzalez, Jude Buffum, Kacey Nelson, Karla Equihua, Katie Cromwell, Kelice Penney, Kermit the Frog, Kevin Kelly, Kevin Pereira, Kit Ellis, Krysta Yang, Larry Kaplan, Laura Weir, Leo Romo, Liz Chiz, Love Ablan, Luis Fernandez, Marc Franklin, Marcia Garcia, Marilyn Skilling, Mary Gibson, Matt Dahlgren, Matt Helgeson, Meggan Scavio, Mike Schmitt, Mike Webster, Melody Pfeiffer, Michael McWhertor, Michelle Valigura, Mike Lunn, Mike Mika, Mike Mitchell, Mikhail Blokh, Mrs. Butts, Nate Carle, Neal Tabachnick, Nick Hurwitch, Nick Luckett, Noah Lane, Nolan Bushnell, Olly Moss, Patrick Neighly, Pinball Pete's, Puck-Man, Ralph Baer, Ralph Bakshi, Randy Barbato, Raph Koster, Reagan Bond, Rob Pereyda, Robert Johnson, Roger Goff, Ruth Crofton, Ryan Babenzien, Ryan Cravens, Ryan Liebowitz, Ryan MacDougall, Ryan Schneider, Scott Belcastro, Scott Flora, Scott Jones, Seamus Blackley, Seth Fisher, Seth Gordon, Seth Killian, Seth Kleinberg, Seth Sternberger, Sgt. Pepper's Pizza, Shane Satterfield, Shawn Baxter, Shawn Smith, Sibel Sunar, Sid Meier, Simon Lamb, Space Invader, Stella, Stephanie Barish, Steve Hendrickson, Steven Lisberger, Ted Biaselli, Thairin Smothers, That $50 Galaga coin-op in the basement that kinda-sorta worked until that rat short-circuited the board by chewing on it, That Pizza Hut on the corner of Arlington Heights and Dundee that had the Tron coin-op, Tim Lapetino, Tim Schafer, Tim Yoon, Tina Ziegler, Todd Casey, Tom Russo, Tony Mora, Toru Iwatani, Trisha Angeles, Tron, Van Burnham, Vicki Sheridan, Video King (where Tim got his first Atari 2600), Vincent DeBenedictis, Wade Beckett, Warren Spector, Wes Phillips, Woody & Vader, Zach Grimsley... and Kevin Toyama for having the balls to publish the first iam8bit book (and for always being a pal, despite the circumstances).

FOREWORD

By Kevin Pereira

I've always had a thing for 8-bit art. Not quite a fetish, but pretty damn close. I once thought it was a childish passion, a nostalgic soft-spot... but as an adult, I realize my appreciation for pixelated, interactive art is steeped in the incredible amount of respect I have for its' creators.

To put it mildly, the videogame artists of the 8os had it rough.

To bring iconic characters and environments to life, they were forced to not only interpret and distill nuance, but sidestep extreme technological limitations.

You see, for many, creativity is often seen as the ability to think outside "the box"; yet for an entire generation of artists in the '8os, artistic hurdles were creatively leapt using *only* the box.

Their brush?

The pixel. A single, solid square.

Their palette?

Limited. A handful of colors at a time.

Their task? Daunting. Create massive explosions; traffic-dodging amphibians; furry, barrel-lobbing beasts; expansive alien worlds; vibrant cathedrals; three-dimensional mountaintop vistas; swarms of sword-brandishing, cartwheeling ninjas; bashful princesses; brow-beaten street fighters; eerie forests with emotive trees; underground, candlelit caverns; larger-than-life monsters that scale cityscapes and devour bikini-clad bathers and/or TNT-toting army men; dragons that spit Technicolor'd bubbles; and of course, a mustachioed-plumber that could run, jump, swim and scale flag poles with the greatest of ease.

On paper, solutions to these challenges seem unattainable, at best; and yet, originality flourished and aesthetic genius prevailed, bringing breathtaking worlds to life, one cartridge at a time.

Ask any child of the NES, who blew with ceremonious anticipation into the bottom of each gray plastic game casing. An entire generation can fondly recount tales of particular titles that forced them to sit back in astonishment as their pupils dilated, eagerly devouring heaps of unseen eye-candy.

It didn't matter that the ocean lacked a mathematically precise reflection of the world above — Thrilla Gorilla still carved the hell out of it!

It didn't matter that each giant gear wasn't dipped in an ultra-reflective, bump-mapped coating — that conveyor belt-riddled warehouse in *Mega Man* packed an ominous, heavy-iron punch.

It didn't matter that Mario's now-iconic mustache was simply two brown boxes beneath a patch of slightly lighter brown squares. His mustache was FUCKING BOSS!

With precious few resources at the artist's disposal, each and every pixel placed represented a chance to communicate an

idea, an emotion, a distinguishable trait. Complex problems, overcome with beautiful simplicity.

That said, we should all take pity on the artists featured within these pages; poor creatives with access to an infinite palette. Comparatively speaking, their tools and technology offer boundless opportunity, and yet their aim is the same: beautiful simplicity.

As they place pen to paper, paint to canvas or clay to fire in interpretive tribute, they have access to a virtually unlimited arsenal, but only one shot: A single image to evoke decades of memories. One single image to render a lifetime of nostalgia.

This is no easy feat, and we should keep that in mind as we celebrate our history with the coming page-turns. Yes, artists of the '80s were forced to create with boxes, but the ones today must create entirely outside of them.

Tl;Dr: This art shit is hard. Respect it.

INTRODUCTION

By Jon M. Gibson

It will never happen again.

Culture is just too quick to rub up against a shiny new piece of tech.

The fact is, the Golden Age of the pixel is dead — an era when grandaddys like Atari, Nintendo, Namco, Capcom, SEGA and others experienced the proverbial equivalent of *Baby's First Photo Album*. All those Polaroid memories, angled toward the marvels and mistakes of a fresh-from-the-womb mega-industry.

We watched as videogames, so crudely, evolved from a singular pixel into a collage of many — morphing from *Pong!* volleys to expeditions through Hyrule.

That heyday has jettisoned — a sucky, bitter truth.

R.I.P.

But it ain't healthy to wallow. We've all got mementos of the past tucked away, and all too quickly, the pungent stuff usually scurries into the spotlight:

I saw my parents split when I was 10, and in particular, witnessed my father, rather effortlessly, walk away from his only son. It's been nearly 20 years since he no-showed for our scheduled reconciliation at the Big Boy on Novi Road.

At 23, I tried to shield my heart, unsuccessfully, as a girl who lived 3,000+ miles away smashed it to smithereens.

And consistently, throughout my entire life, I've seen a lot of friendships implode, and with each one, you can't help but analyze why and attempt to stamp blame. Whose fault was it?

But it doesn't fucking matter.

I hear far too often from so-called "purists" that modern videogames, as a whole, have lost the charm that the classics once had. That old-school is the one and only — how vinyl is superior to digital, or thumbing through paper pages sure beats scrolling.

It's bullshit. And so short-sighted.

My dad was a dick, but it's his nasty traits that, through

MEMORIES ARE INHERENTLY PERSONAL.
THEY ARE BEAUTIFULLY SPECIFIC.

my childhood, I aimed to change in myself. Emma broke me up inside, but she also showed me what I really needed in a relationship, not what I *thought* I did. And all those friendships that went kaput — well, people follow different paths, and it's an equal pardon to both parties when shit just doesn't click anymore.

Why sit and stew? Where's the purpose in punching the wall? Lovelier is the positive euphoria of knowledge gained — and that should always take the front seat.

Nostalgia isn't about the "could've been" or "should've been" — but about the remembrance and lessons thereof.

Memories are inherently personal. They are of you and only you — as unique as unique gets. They are beautifully specific.

And rarely are they shared beyond the insulated circle of BFFs or significant others... if even then.

iam8bit is one such forum for incredible, personal intimacy, in which artists bear their souls through childhood fantasies and delusions put to a variety of media, be it paint or sculpture or something totally unexpected.

It's the ultimate "show and tell" — a collection of experiences, each perfectly different than the next. The emotions are evident with every brushstroke — the wonderment of exploring the Mushroom Kingdom, snapshotting all its oddities like a Japanese tourist; the prophecy-fulfilling quests in *The Legend of Zelda*, *Final Fantasy* and countless others, in which you are "The Chosen One," born and bred to rescue the world from the clutches of evil, all from the comfort of a muddied throw rug in a dingy basement; and the simple pleasures, and resulting "fucks," of an imprecise toggle or mash. (*Contra*, you motherfucker!)

So it's not that games of the '70s and '80s were *better*; they were just *looser*, *broader* and *wilier*. They had a spark — a charming, sexy incompleteness — that was all too fun to frolic in. And it's because we were kids then — and adults now — that those memories can be translated into such radical artworks.

It's about filling in the gaping holes left vacant by infantile graphics.

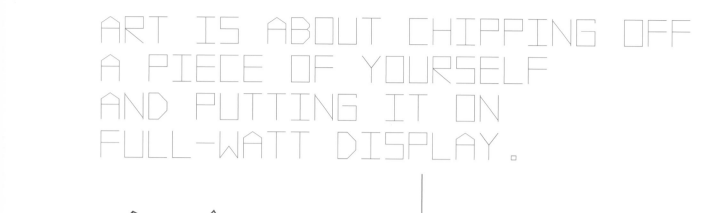

ART IS ABOUT CHIPPING OFF A PIECE OF YOURSELF AND PUTTING IT ON FULL-WATT DISPLAY.

The artists of iam8bit may be as different as the dozens of countries and cultures they hail from, but unity is in their ability to very significantly — and so caringly — pave that unfinished freeway. Each piece is a direct feed into their subconscious, because our subconscious was working crazy overtime back then. We all recognize Samus as a perfect ten hottie these days, but when her body was just a few pixels tall in *Metroid*, her curves were about as orgasmic as scrambled cable porno — hard-edged, ninety degree angles; not even close to the smooth, continuous flow from breast to hip that we get to admire today in 1080p.

My nephew, now just becoming a teenager, will never grasp the truths in this introduction. To him, black and white is wrinkly and gross. He'll never see the soul behind the pixel, nor will he ever use the word "sexy" to describe one.

But you picked up this book because you're not my nephew, because you have a lingering twitch for some retro game that never got resolved — a high score never surmounted; a level never completed; a battle KO'd when you were so fucking sure your pal cheated. Couple those experiences with a first kiss, a hard goodbye, an embarrassing moment, a joyous hoorah, the death of a pet, divorce, love, anguish, rage – now we're talkin' about something fiery.

Impassioned.

Contextual.

Life is a constant collision, and nothing is as simple as it just looking "cool". There's always more at play.

Ultimately, the reason I spewed some of my own substantially personal baggage here is kick start your inner Freud.

There's a reason why *E.T.* still resonates, and why you'd take lease on an apartment in the Wizarding World tomorrow if it were real. It's the exact reason why The Beatles always seemed to strum the perfect chords, and why Norman Rockwell always nailed it!

It's because art is about chipping off a piece of yourself and putting it on full-watt display — be it your fantastic journeys, your morbid delusions or your exquisite perversions.

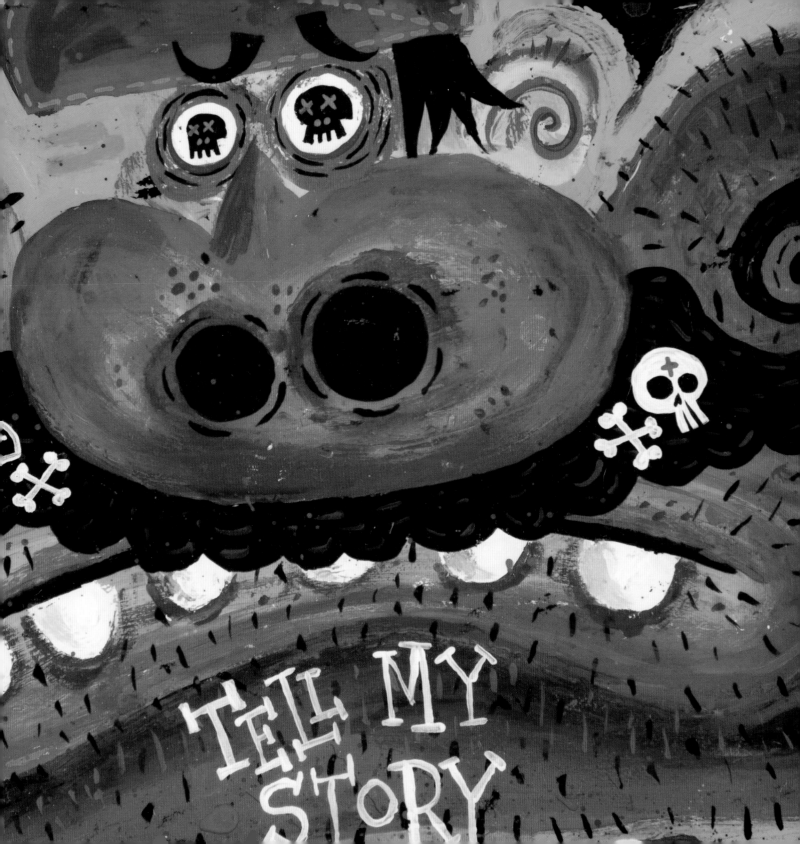

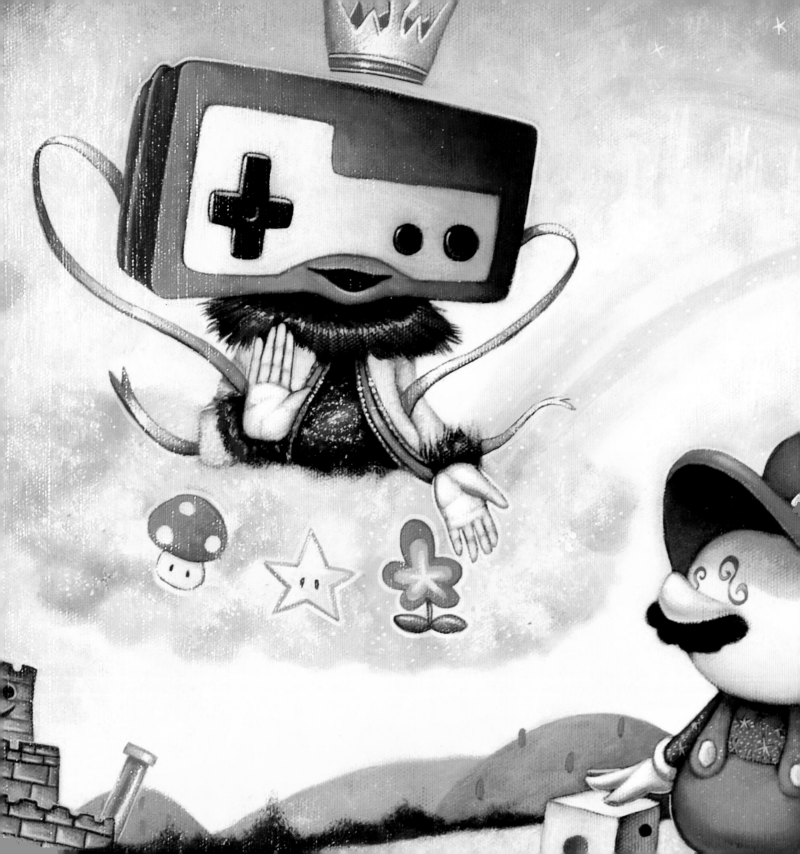

WHILE NOT EVERYONE MIGHT CONNECT WITH YOUR WORK...

SOMEONE.

SOMEWHERE.

WILL.

Imagination, and its inherent psyche, are difficult to share.

It's vulnerability super-sized.

It's about being downright microscopic with your audience, and considering every personal, painful molecular detail of an idea, because while not everyone might connect with your work...

Someone.

Somewhere.

Will.

And with nearly seven billion people on this planet, you can bet your ass that there are a lot of someones that have dreamt, pondered or experienced similar things to you.

The art in this book isn't just character design remixes; it's very personal moments sharing a common theme:

Videogames.

And to be certain, videogames of a particularly exciting era — a time when gamemakers not only wanted you to use your imagination.

They demanded it.

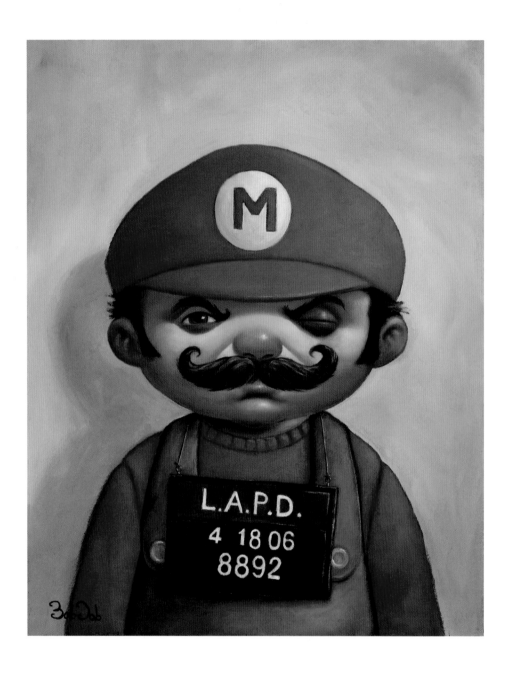

BOB DOB
Mario
acrylic on panel — 8 x 10 inches
inspiration: **Super Mario Bros. series**

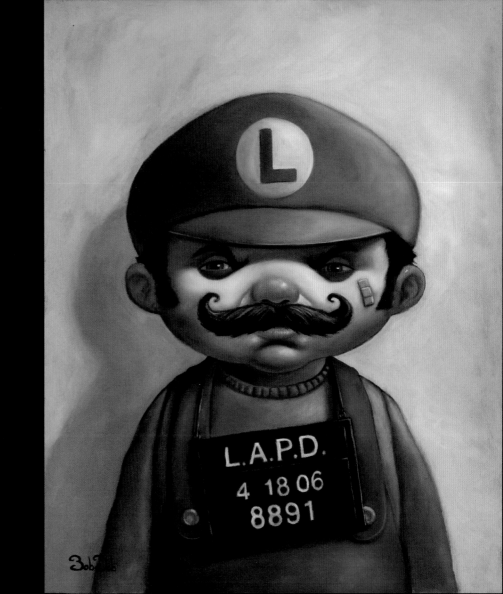

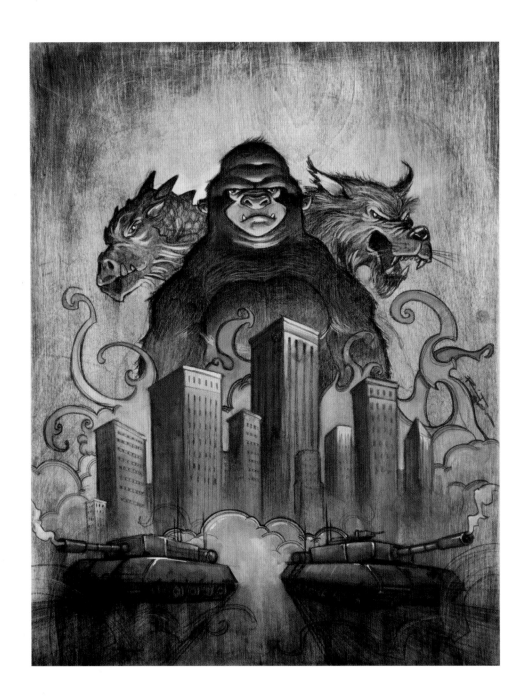

RICH TUZON
Rampage
acrylic on board — 14 x 18 inches
inspiration: **Rampage** (arcade)

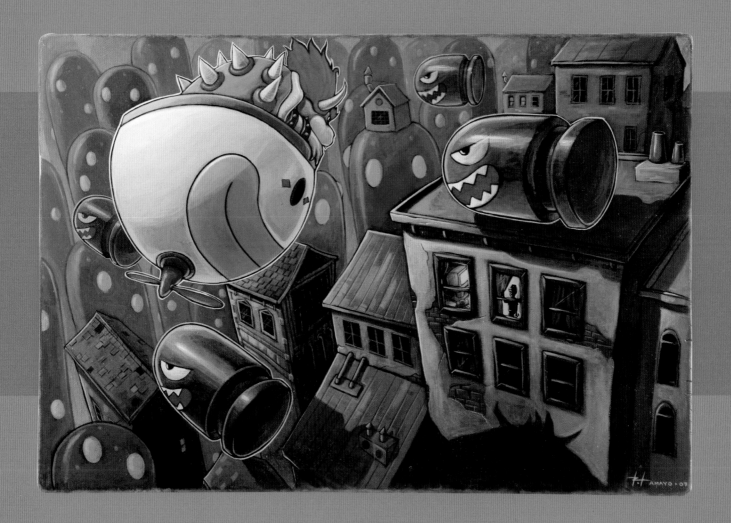

ROLAND TOMAYO
The 4am Showdown
acrylic on board — 22 x 15 inches
inspiration: **Super Mario World** (SNES)

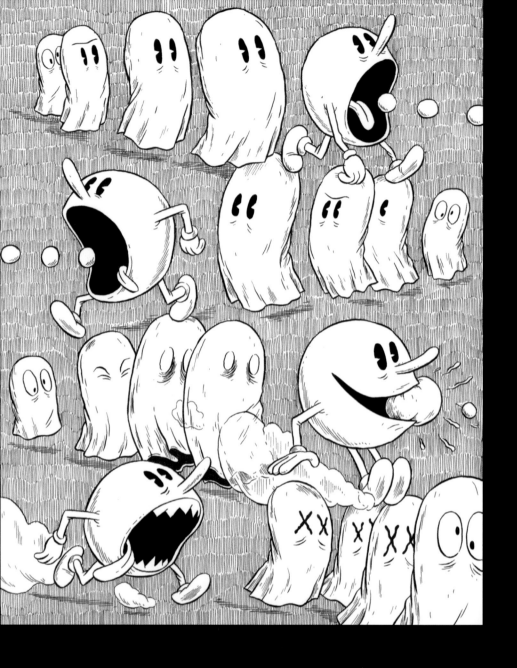

MARTIN CENDREDA
Quarter Mile Dash
watercolor and ink on paper — 8 x 16 inches
Inspiration: **Pac-Man** (arcade)

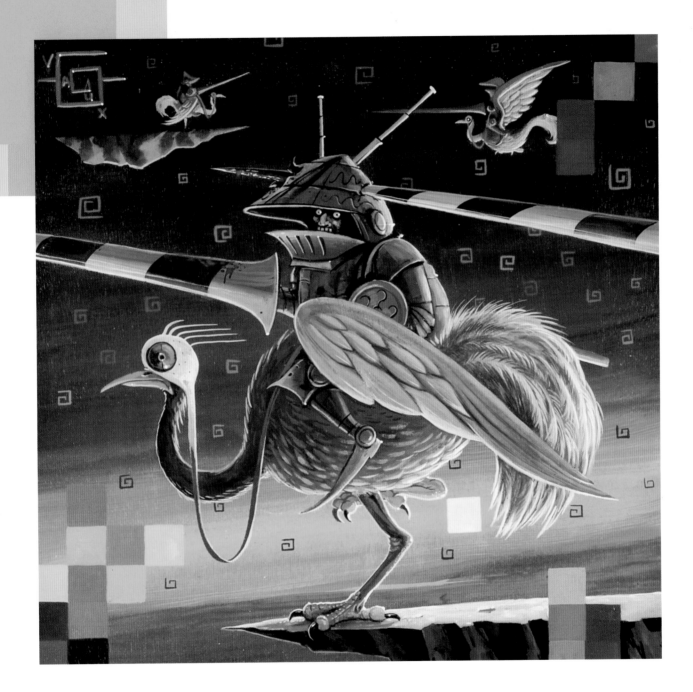

JOE VAUX
Joust
acrylic on wood panel — 20 x 20 inches
inspiration: **Joust** (arcade)

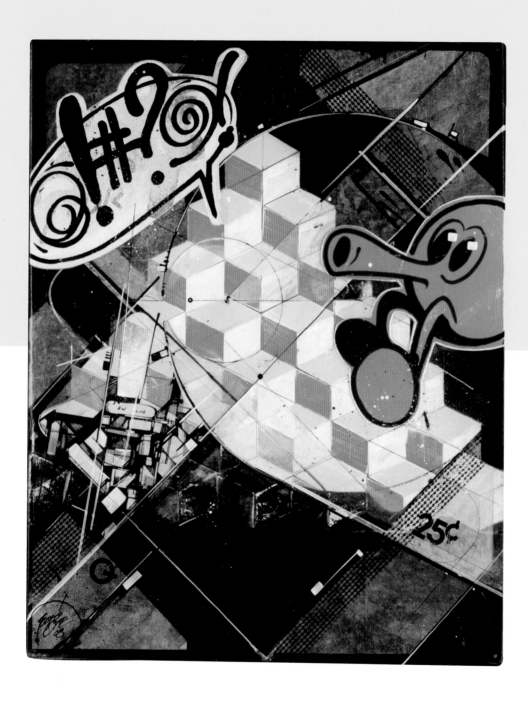

KOFIE ONE
Drafted Q*bert
mixed media — 16 x 20 inches
inspiration: **Q*bert** (arcade)

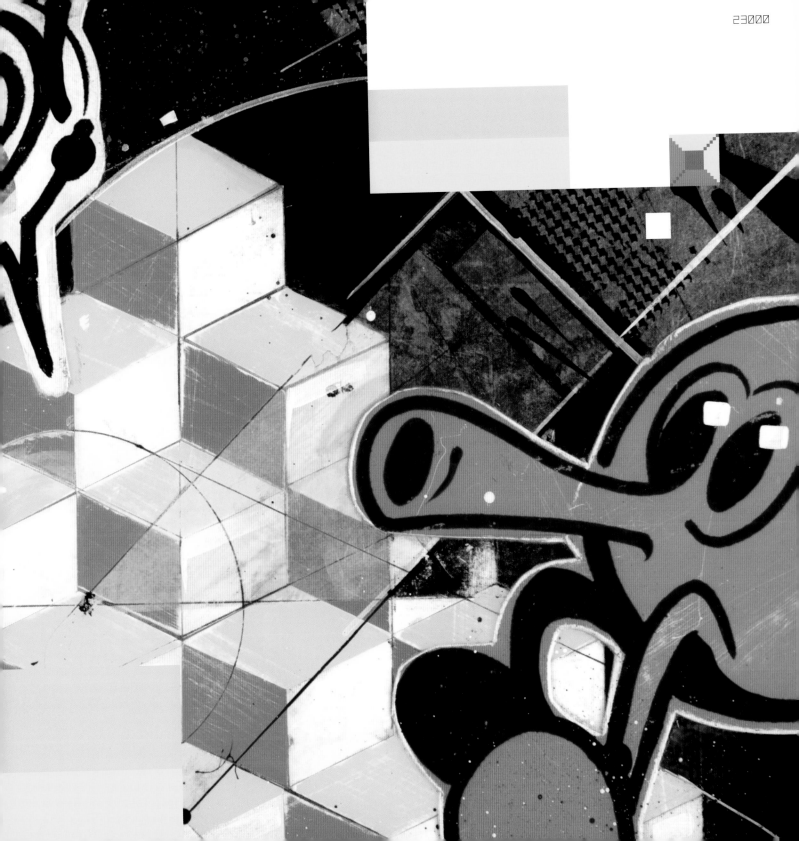

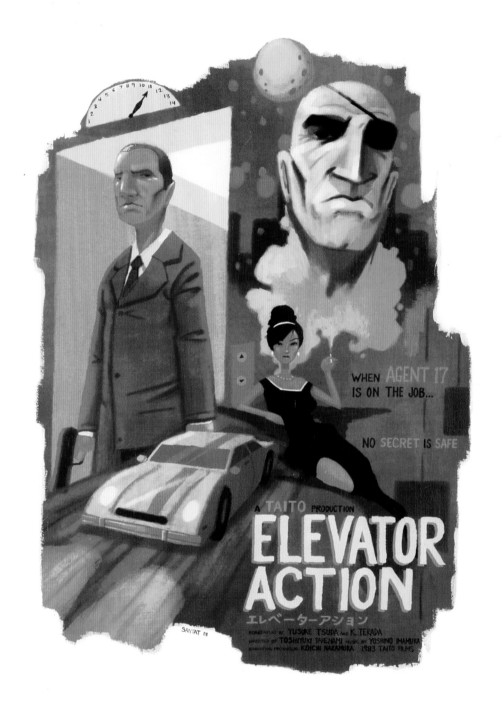

DAN SANTAT
Elevator Action
acrylic on paper — 16½ x 20½ inches
inspiration: **Elevator Action** (arcade)

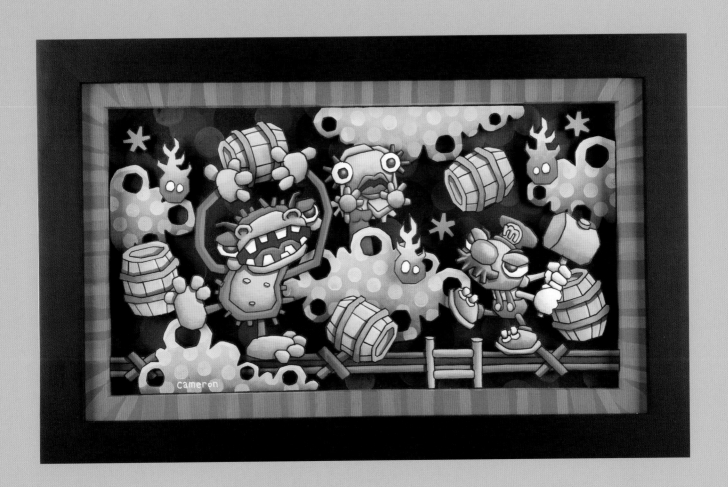

CAMERON TIEDE
Kong'd
acrylic on wood — 30 x 19 inches
inspiration: **Donkey Kong** (arcade)

26000

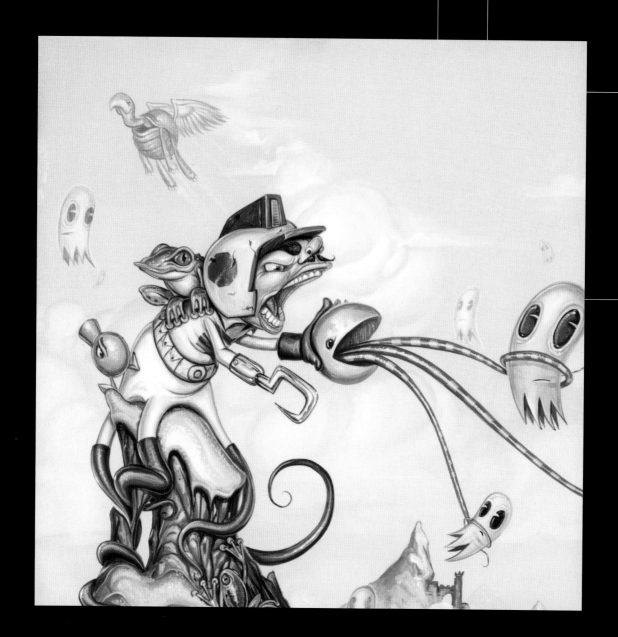

GREG "CRAOLA" SIMKINS
The Further Adventures of...
acrylic on canvas — 12 x 12 inches
inspiration: **Dig Dug, Frogger, Pac-Man, Q*bert** (arcade); **Super Mario Bros.** (NES)

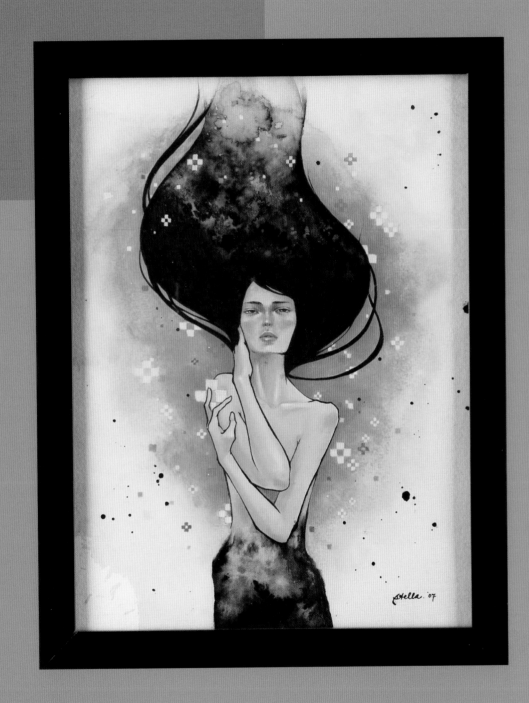

STELLA IM HULTBERG
In Bits and Pieces...
ink and oil on tea-stained paper — 10 x 13 inches
inspiration: **Nintendo Entertainment System**

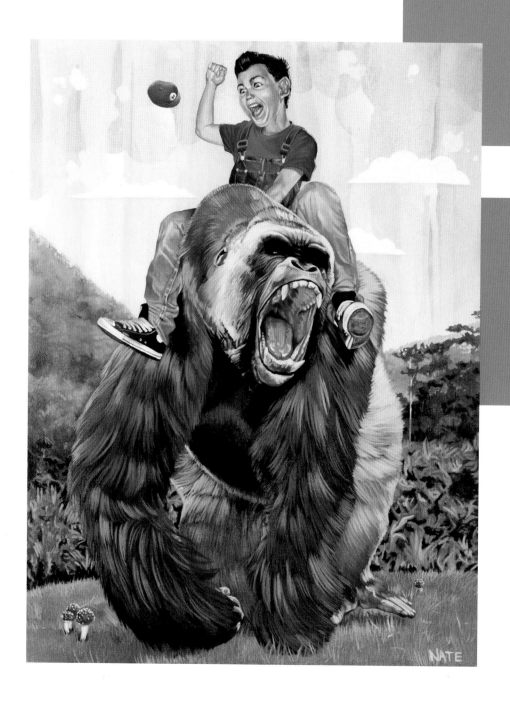

NATE FRIZZELL
Conquering Kong
acrylic on board — 18 x 24 inches
inspiration: **Donkey Kong** (arcade)

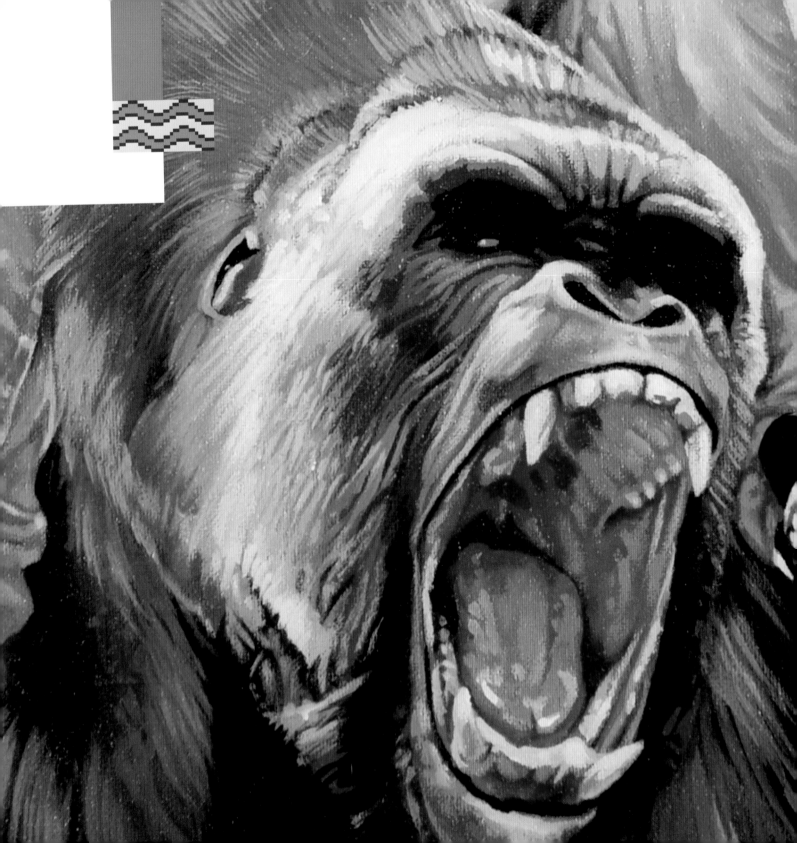

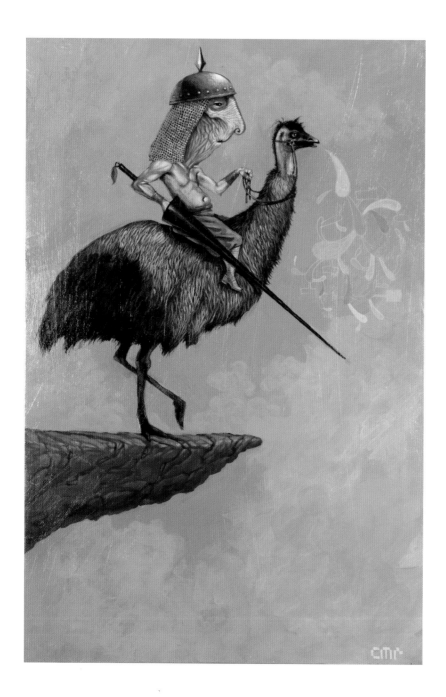

CHRIS RYNIAK
One-Up
acrylic on wood — 12 x 18 inches
inspiration: **Joust** (arcade)

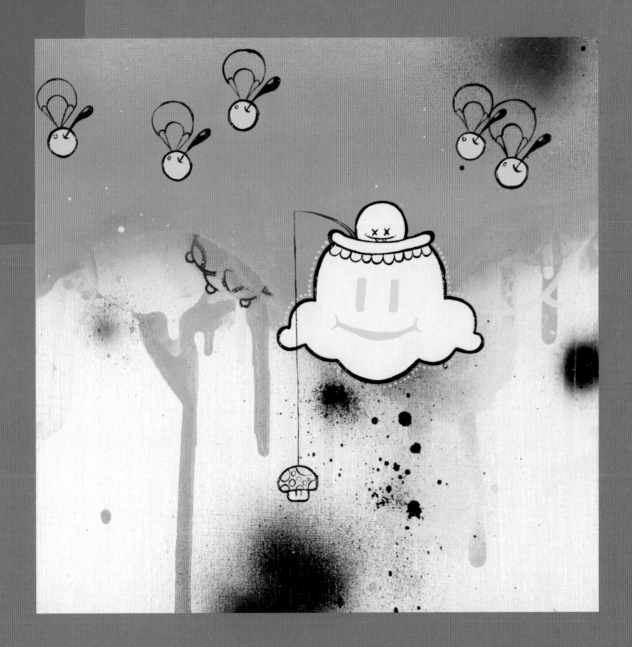

BUFF MONSTER
Happy Gold
acrylic and spray paint on wood — 10 x 10 inches
inspiration: Super Mario Bros. series

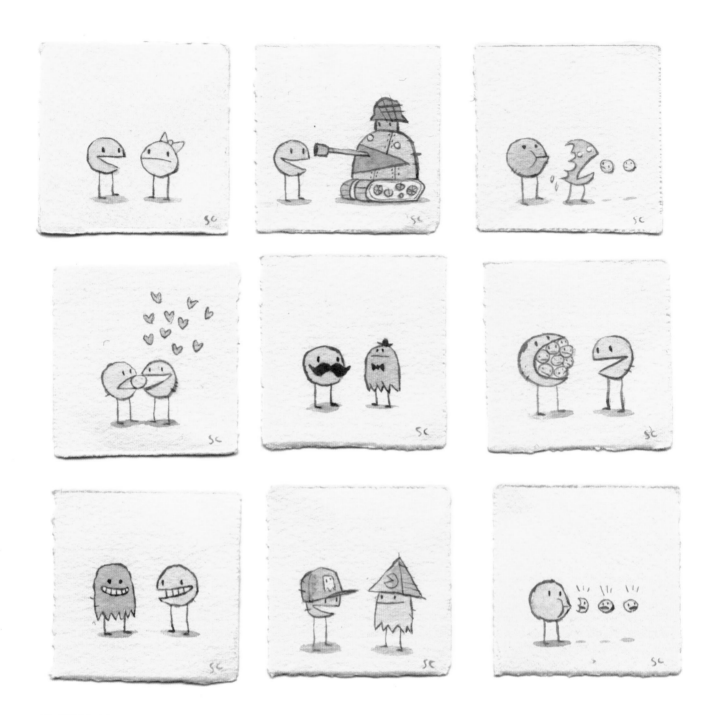

SCOTT C
The Pac-Mans
watercolor on paper — 4 x 4 inches each
inspiration: **Pac-Man** (arcade)

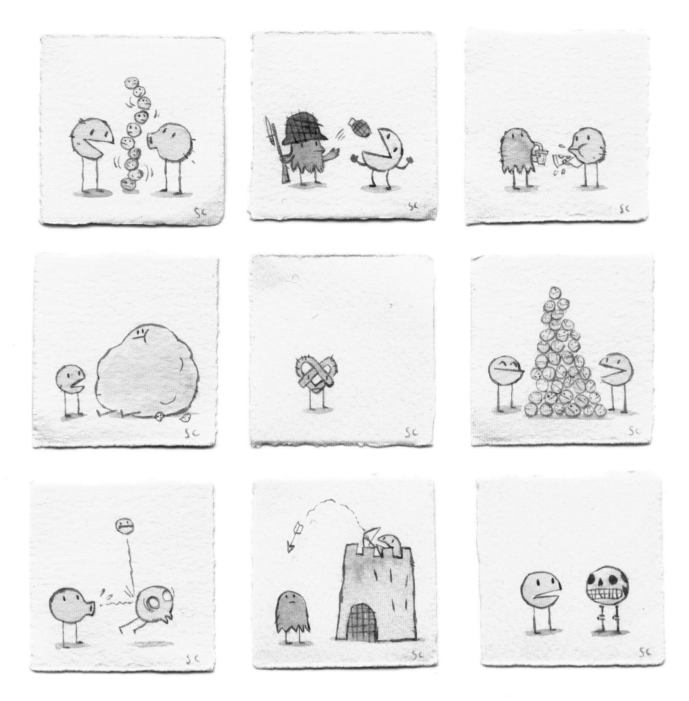

SCOTT C
The Pac-Mans
watercolor on paper — 4 x 4 inches each
inspiration: Pac-Man (arcade)

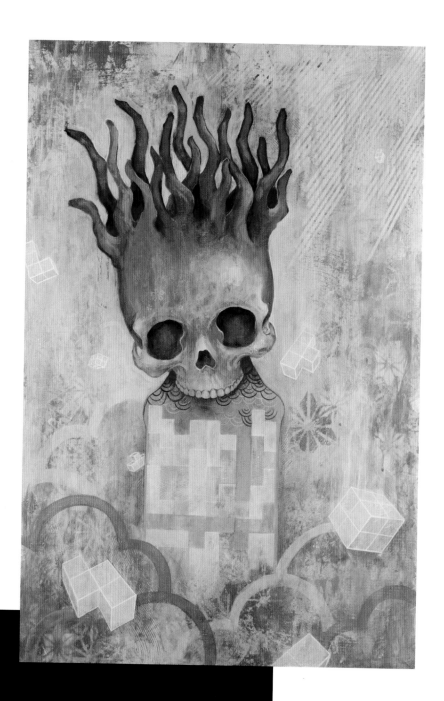

YOSKAY YAMAMOTO
Waiting in Vain
acrylic on wood — 24 x 36 inches
inspiration: **Tetris** (NES)

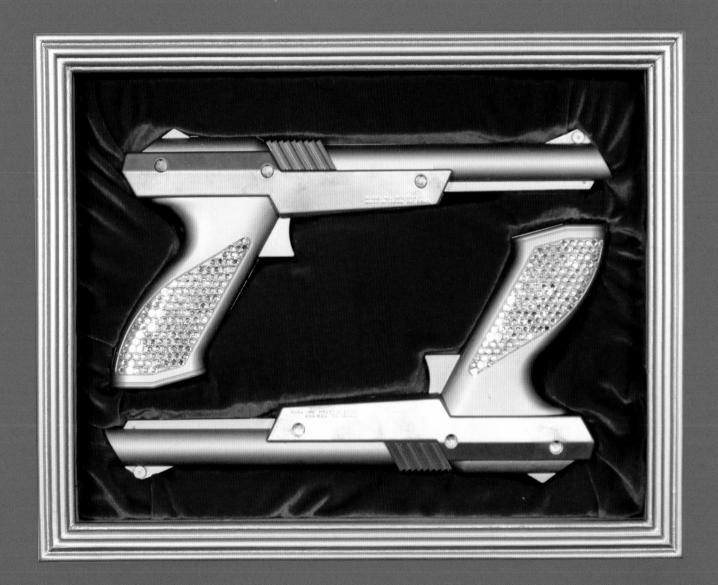

PETER GRONQUIST
Pistols @ Dawn
mixed media — 14¾ x 11¾ inches
inspiration: Duck Hunt (NES)

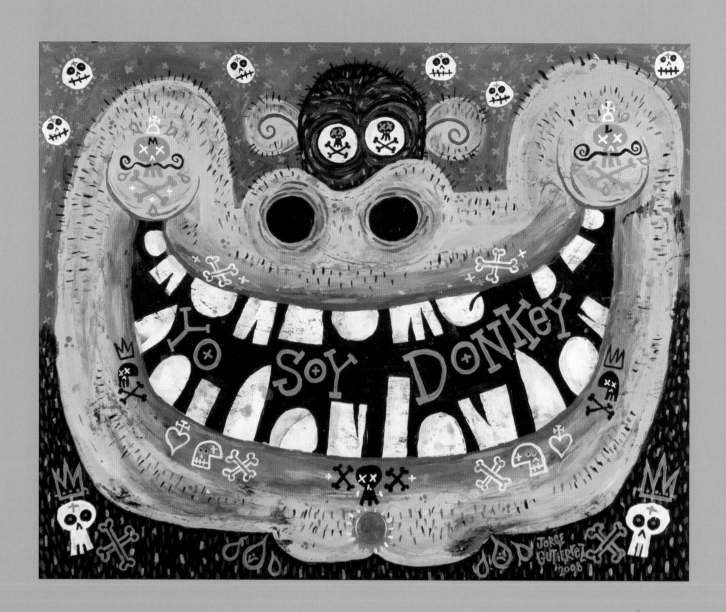

JORGE R. GUTIERREZ
Bring Me the Head of Mario & Luigi
acrylic on wood — 18 x 14 inches
inspiration: **Donkey Kong** (arcade)

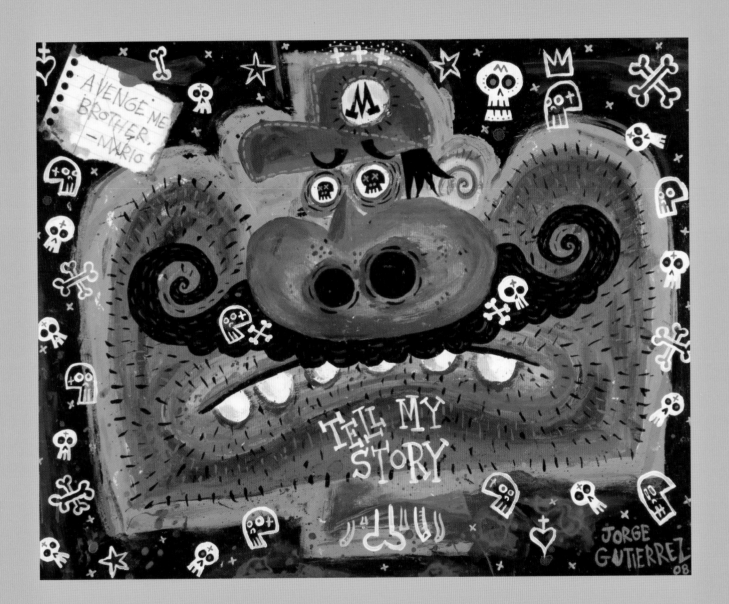

JORGE R. GUTIERREZ
My name is Mario. You killed my brother. Prepare to die!
acrylic on wood — 18 x 14 inches
inspiration: **Super Mario Bros. series**

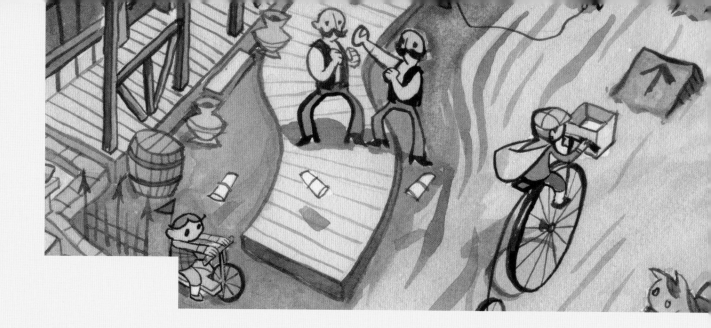

PAPERBOY WAS MY FAVORITE

arcade game, mainly because of the actual BMX bike handle controls. It felt so good to play that game. And I loved that some houses on the street were good and some were evil. That would be sweet in real life.

I felt it would be interesting to see all of these suburban elements 100 years earlier in a Wild West town. It would have been much muddier in the streets back then, but as long as you had BMX bike handles on your penny-farthing, you would be in good shape.

– Scott C

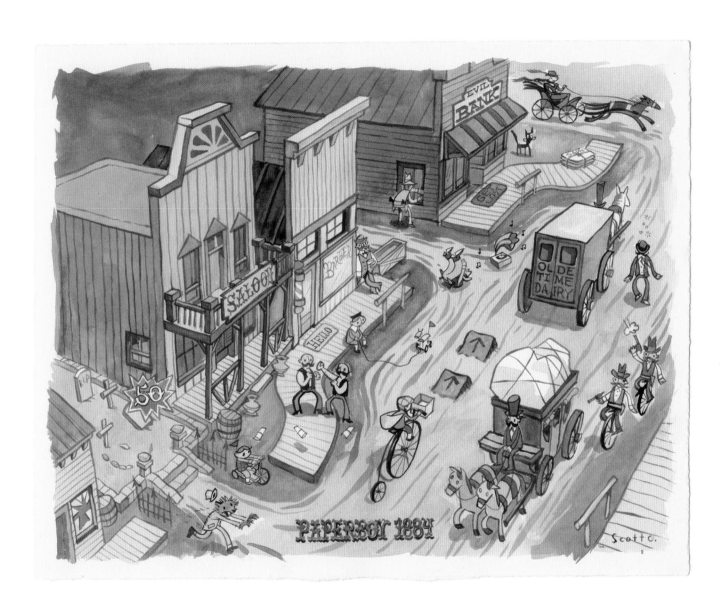

SCOTT C
Ye Olde Paperboy
watercolor on paper — 17 x 14½ inches
inspiration: **Paperboy** (arcade)

JESSE LEDOUX
Dig Dug Dig Dug Dig Dug Dig Dug Dig Dug Dig Dug
acrylic on canvas — 11 x 14 inches
inspiration: **Dig Dug** (arcade)

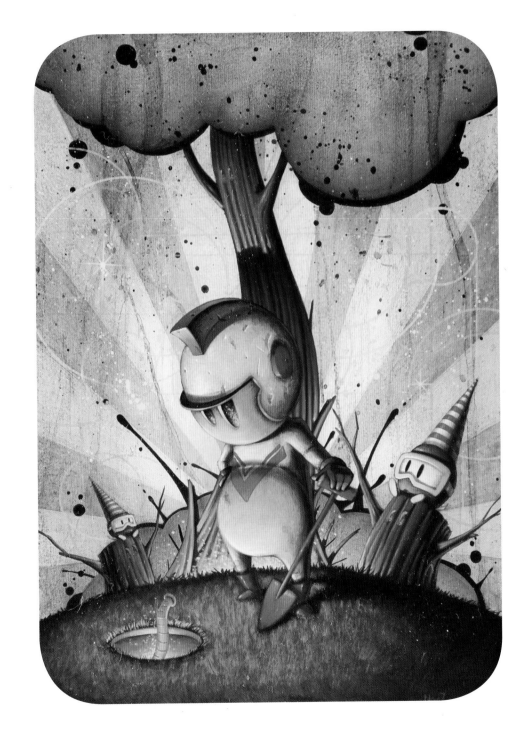

NATHAN OTA
Dug Out of Luck
acrylic on board — 5 x 7 inches
inspiration: **Dig Dug** (arcade)

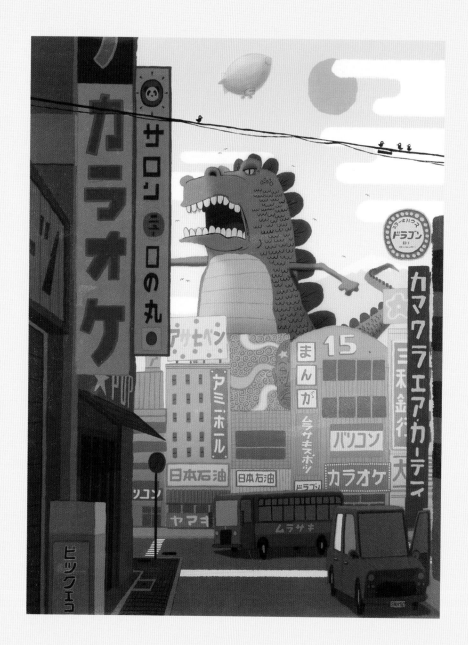

DAN SANTAT
Rampage
acrylic on paper — 16 x 20 inches
inspiration: **Rampage** (arcade)

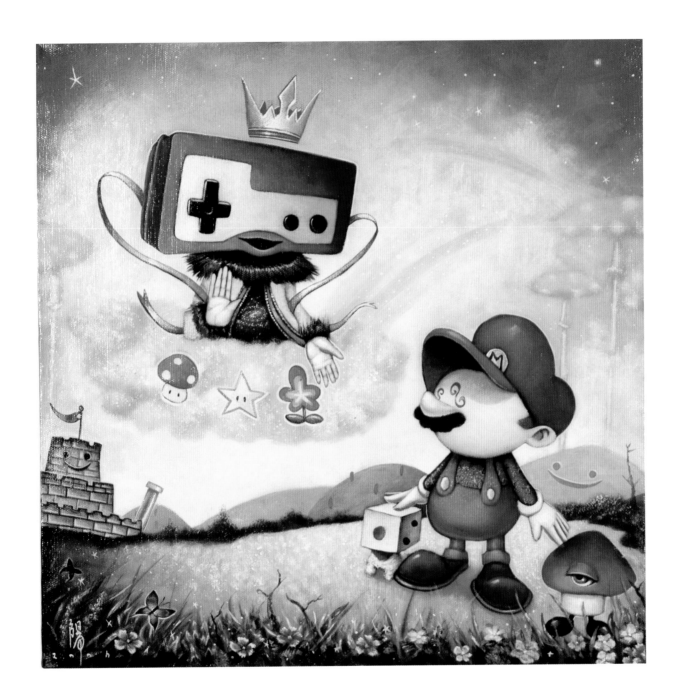

YOSUKE UENO
Beginning the New Adventure
acrylic on canvas — 15¾ x 15¾ inches
inspiration: **Super Mario Bros.** (Famicom)

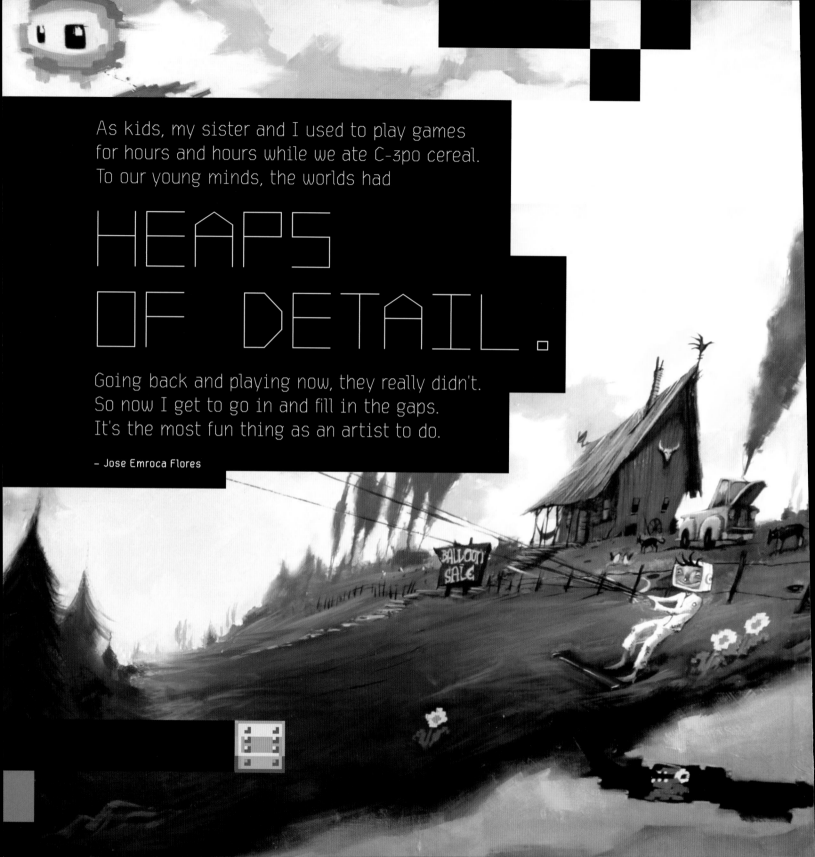

As kids, my sister and I used to play games
for hours and hours while we ate C-3po cereal.
To our young minds, the worlds had

HEAPS
OF DETAIL.

Going back and playing now, they really didn't.
So now I get to go in and fill in the gaps.
It's the most fun thing as an artist to do.

– Jose Emroca Flores

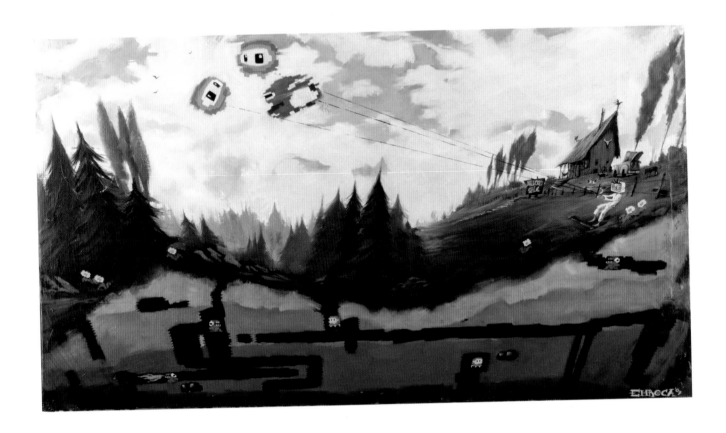

JOSE EMROCA FLORES

8-Bit Underground

oil on wood — 36 x 19½ inches

inspiration: **Dig Dug** (arcade)

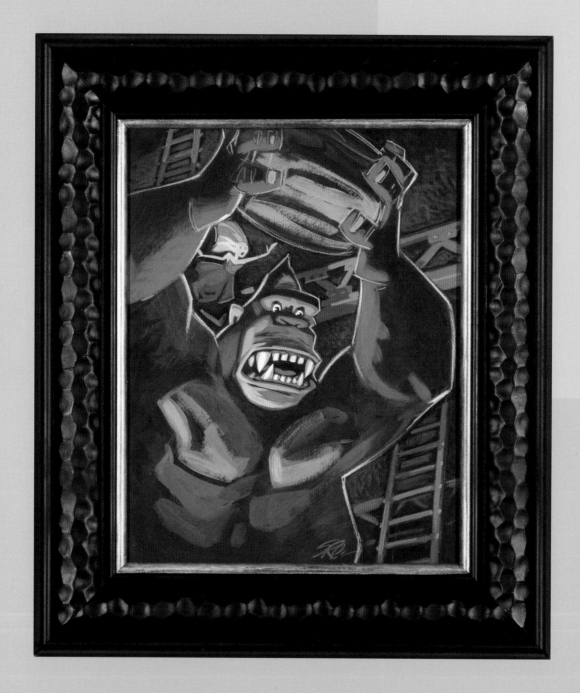

STEVE PURCELL
A God in the World He Once Knew
acrylic on board — 11½ x 13½ inches
inspiration: **Donkey Kong** (arcade)

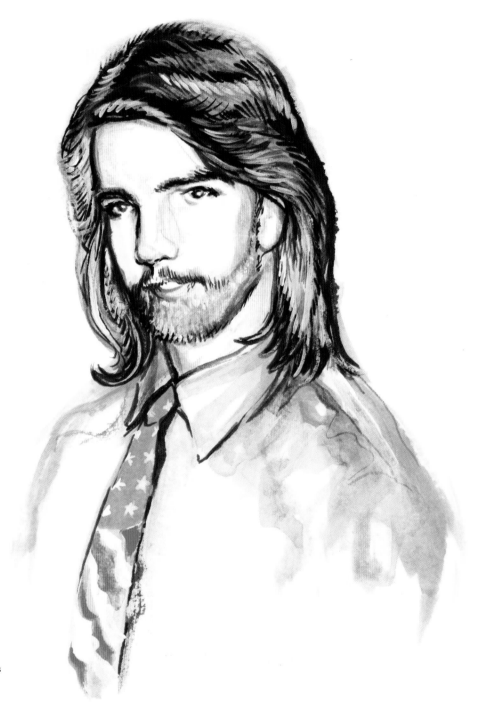

ΑΙΥΑΝΑ UDESEN
Billy Mitchell
acrylic on board — 9½ x 9½ inches
inspiration: **The King of Kong: A Fistful of Quarters**

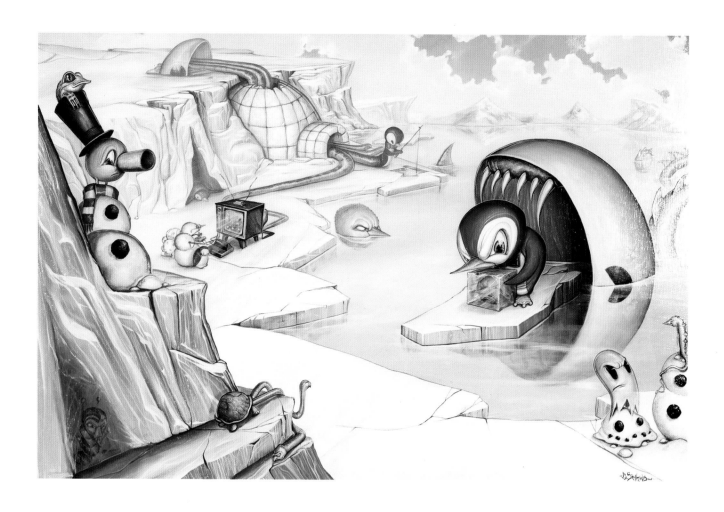

GREG "CRAOLA" SIMKINS
Pengo! Pengo!
acrylic on canvas — 36 x 24 inches
inspiration: Frogger, Pac-Man, Pengo, Q*bert, Space Invaders (arcade); Super Mario Bros. (NES)

Hey you! Yeah you — Pengo! You slightly remind me of Pac-Man.
Snowbees are kind of like ghost monsters, and mazes look a lot like... mazes.

WHO ARE YOU
TRYING TO FOOL?

I think you need to think about what you did. Sinner.

– Greg "Craola" Simkins

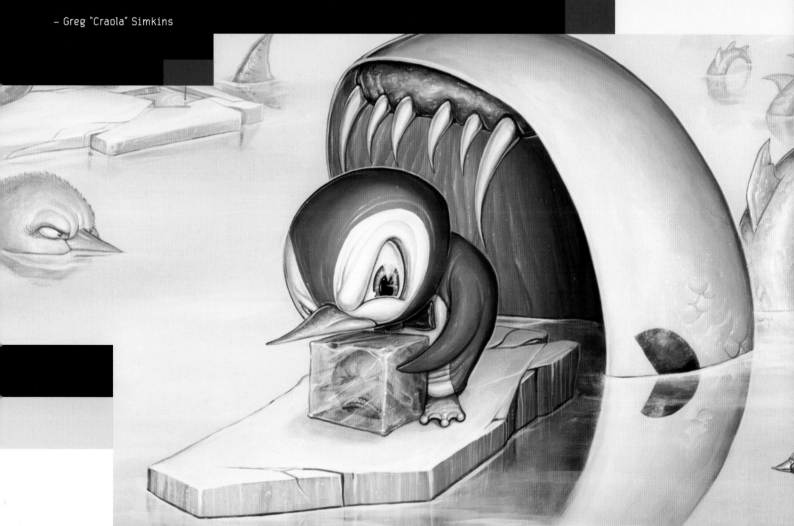

CHRIS BISHOP
Falling Mega Man
acrylic on canvas — 18 x 24 inches

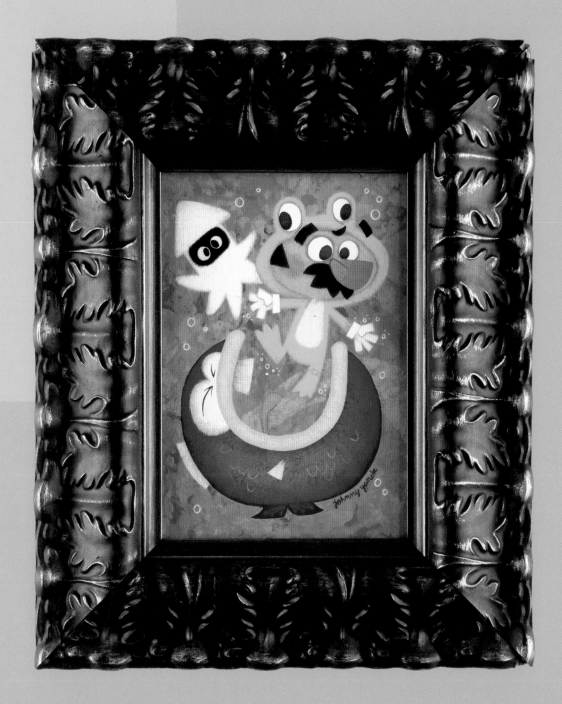

JOHNNY YANOK
Double Trouble
acrylic on panel — 5 x 7 inches
inspiration: **Super Mario Bros. 3** (NES)

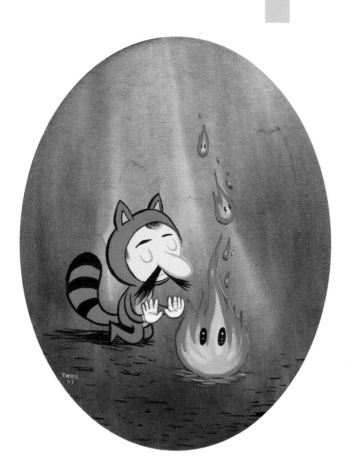

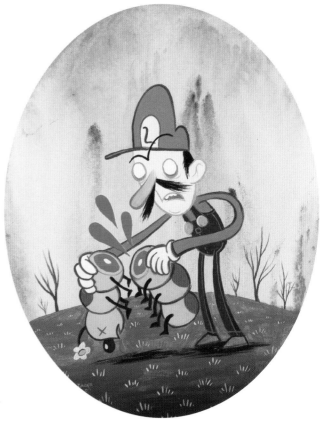

JEREMY TINDER
Face Your Fears
acrylic on canvas — 8 x 10 inches
inspiration: **Super Mario World** (SNES)

JEREMY TINDER
Night in the Woods
acrylic on canvas — 8 x 10 inches
inspiration: **Super Mario Bros. 3** (NES)

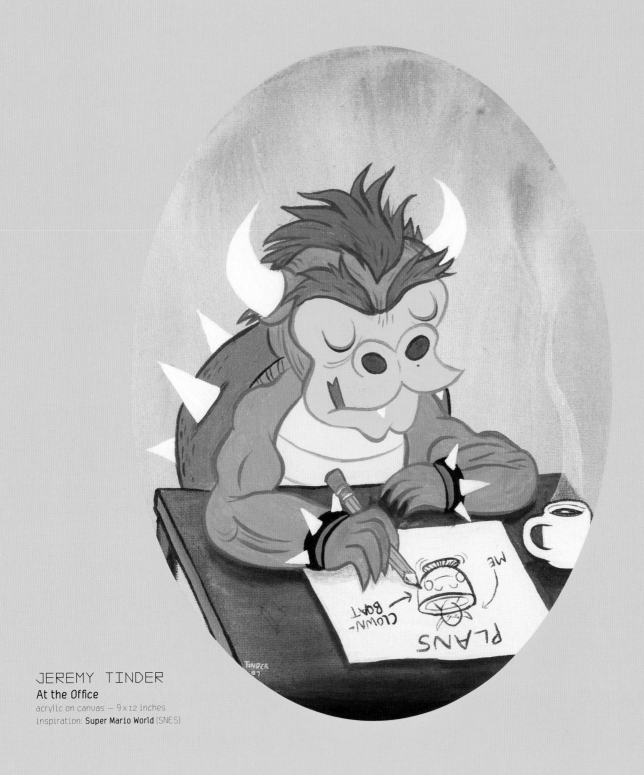

JEREMY TINDER
At the Office
acrylic on canvas — 9 x 12 inches
inspiration: **Super Mario World** (SNES)

The brothers Mario remind me of all the long hours
my own brother and I sat in front of the TV taking turns playing,
hammering buttons, staying up past our bedtimes,

THROWING THE CONTROLLER.

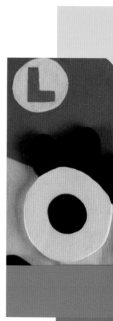

blaming the NES, eating pretzels
and endlessly trying to conquer that game.
Mario is a huge part of our childhood —
a staple of joy, discovery and frustration...
and without him, we wouldn't be who we are today.

– Gabe Swarr

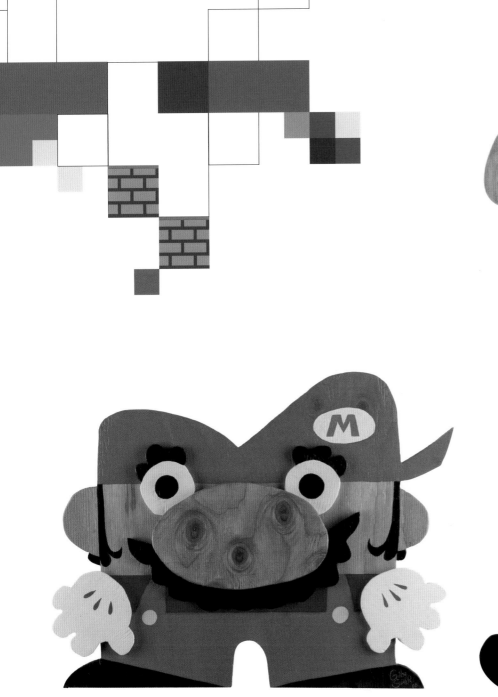

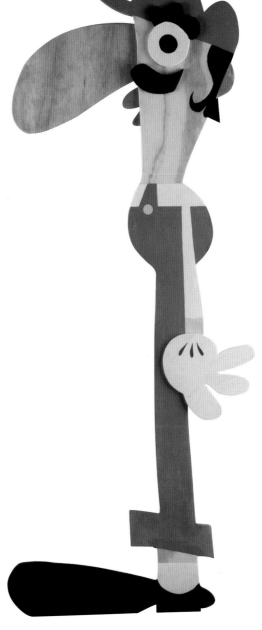

GABE SWARR
Wooden Mario
acrylic on wood — 22 x 17 inches
inspiration: **Super Mario Bros. series**

GABE SWARR
Wooden Luigi
acrylic on wood — 15 x 42 inches
inspiration: **Super Mario Bros. series**

JOHN HARVATINE IV
Pack n' Pain
mixed media/photography — 30 x 20 inches
inspiration: **Pac-Man** (arcade)

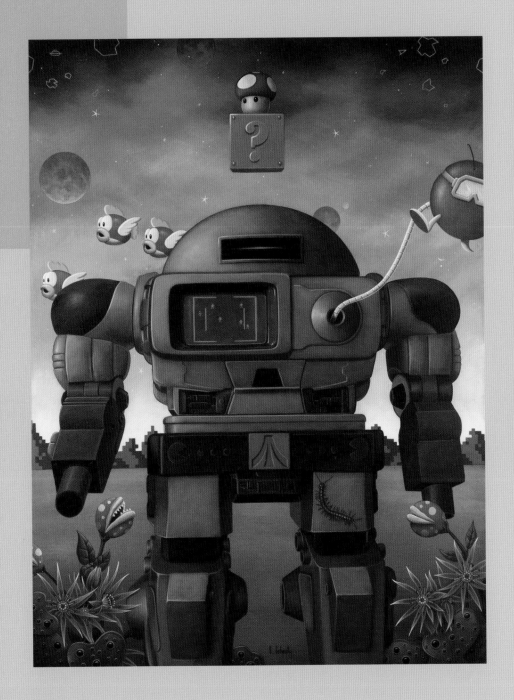

SCOTT SCHEIDLY
Berzerk
acrylic on wood — 18 x 24 inches
inspiration: **Berzerk, Centipede, Combat, Dig Dug, Pac-Man, Pong!** (arcade); **Super Mario Bros.** series

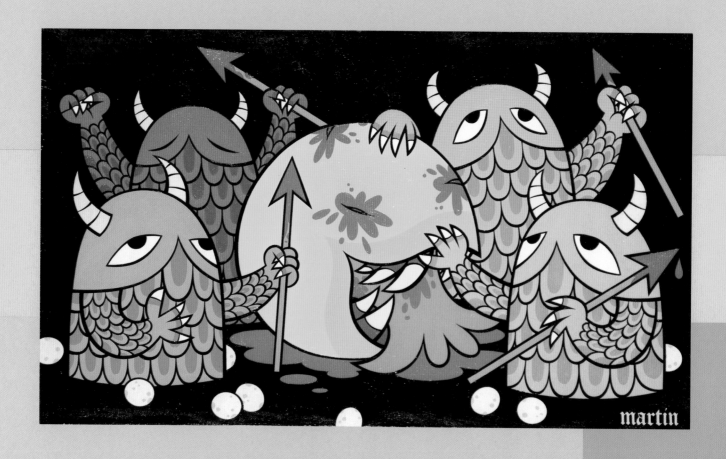

MARTIN ONTIVEROS
The Beast is Dead
acrylic and ink on board — 12 x 8¾ inches
inspiration: **Pac-Man** (arcade)

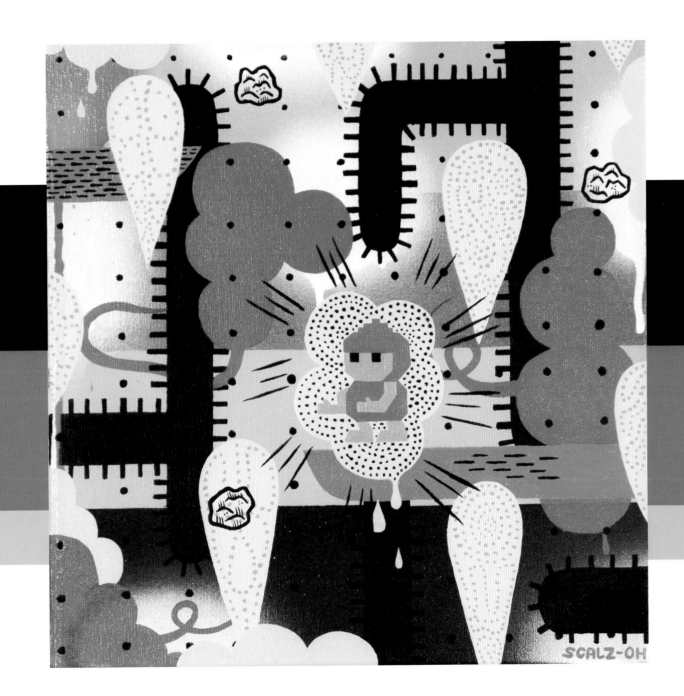

KEVIN SCALZO
I Dig the Dug
mixed media on canvas — 12 x 12 inches
inspiration: **Dig Dug** (arcade)

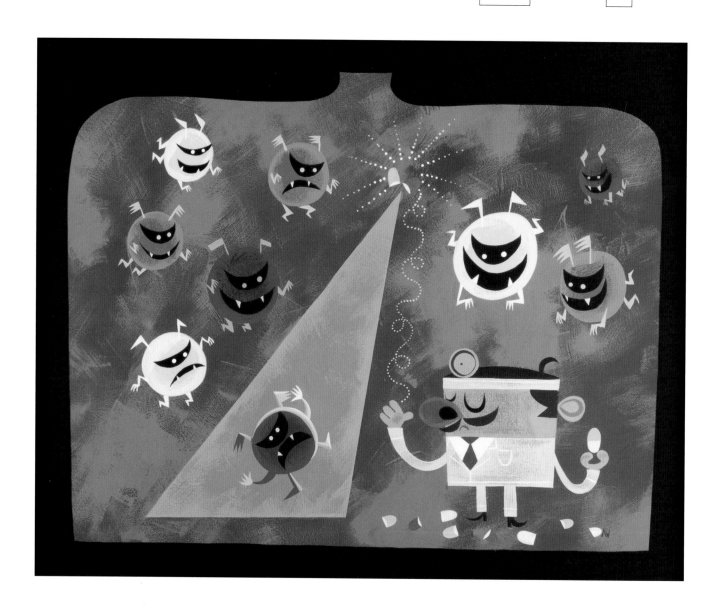

AMANDA VISELL
One Pill Left
acrylic on wood — 20 x 16 inches
inspiration: **Dr. Mario** (NES)

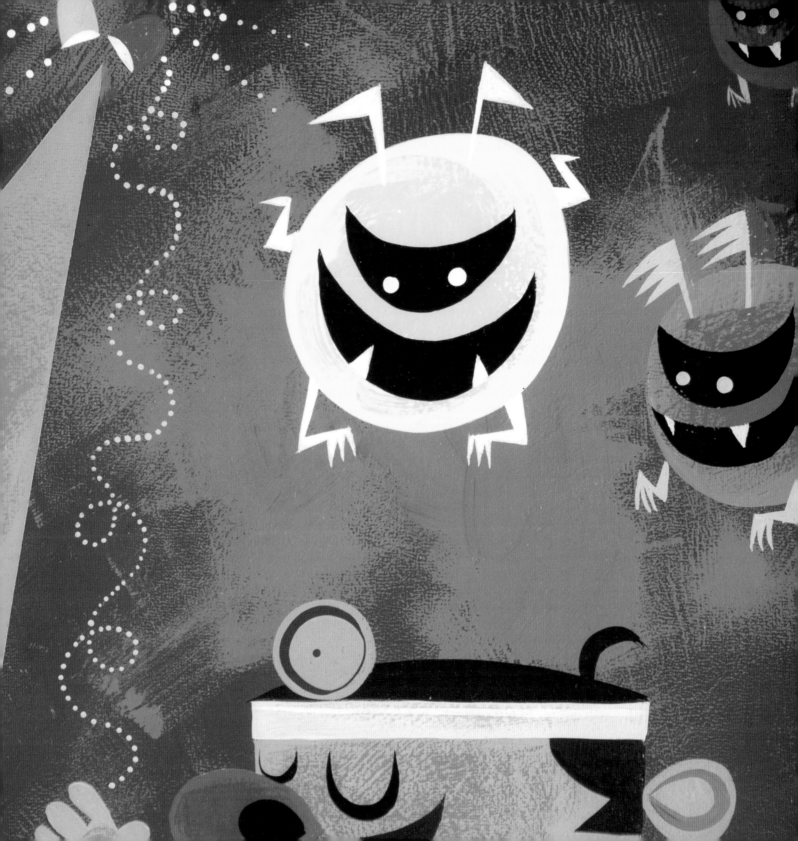

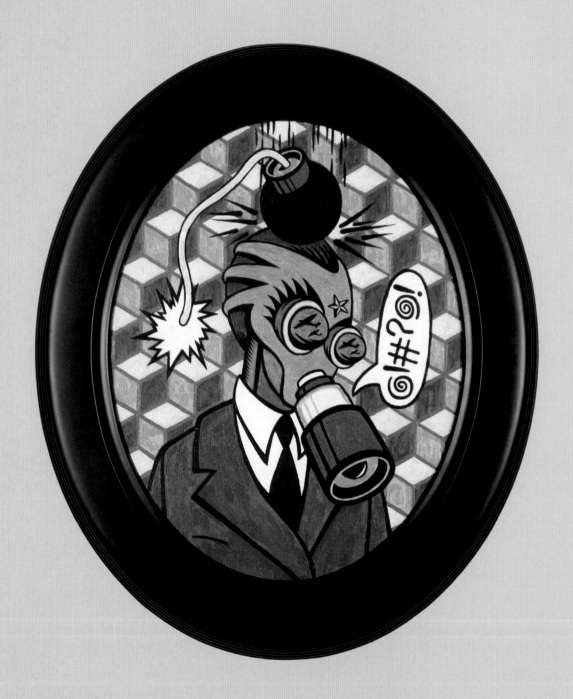

MAX GRUNDY
Q*bert in Iraq
acrylic on canvas — 10⅜ x 12¼ inches
inspiration: **Q*bert** (arcade)

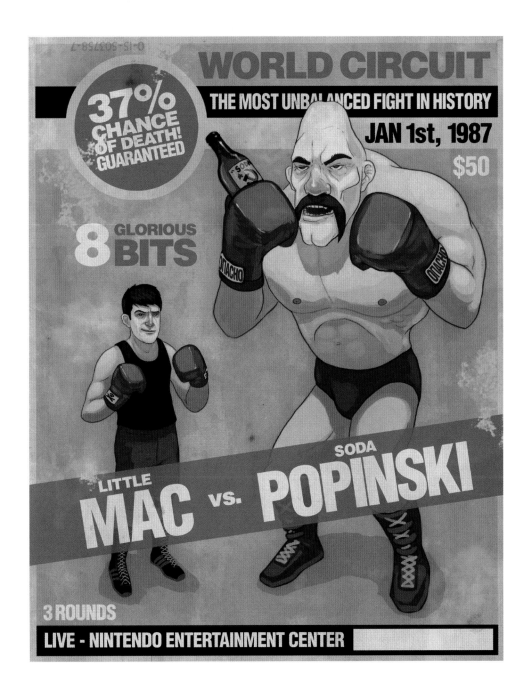

MIKE MITCHELL
1987 Was a GREAT Year
digital illustration on canvas — 11 x 14 inches
inspiration: **Mike Tyson's Punch-Out!!** (NES)

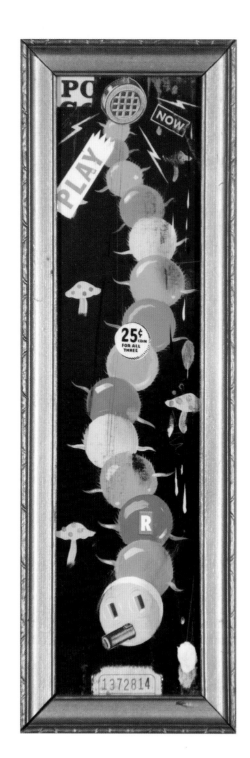

RYAN HESHKA
Centipede
acrylic and mixed media on board — 2½ x 9½ inches
inspiration: **Centipede** (arcade)

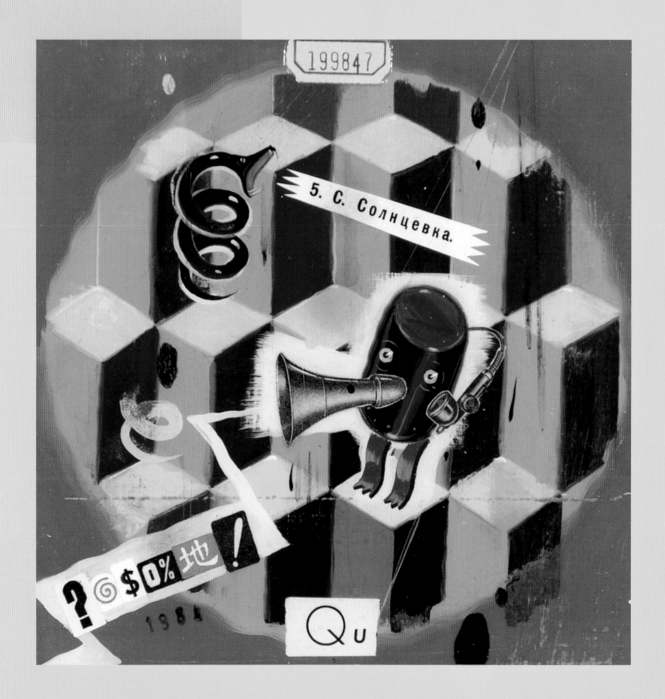

5. С. Солнцевка.

199847

RYAN HESHKA
Q*bert Cold War
acrylic and mixed media on board — 6 x 6 inches
inspiration: **Q*bert** (arcade)

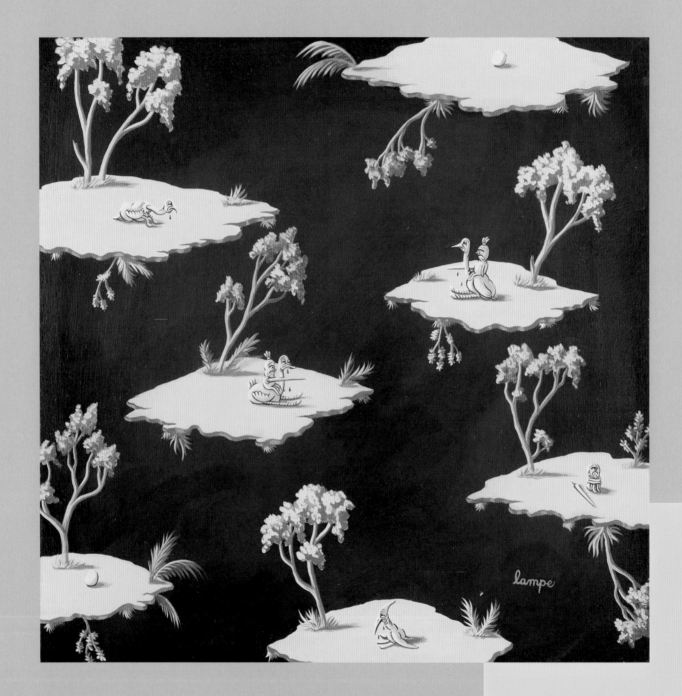

TRAVIS LAMPE
Sad Joust
acrylic on board — 12 x 12 inches
inspiration: **Joust** (arcade)

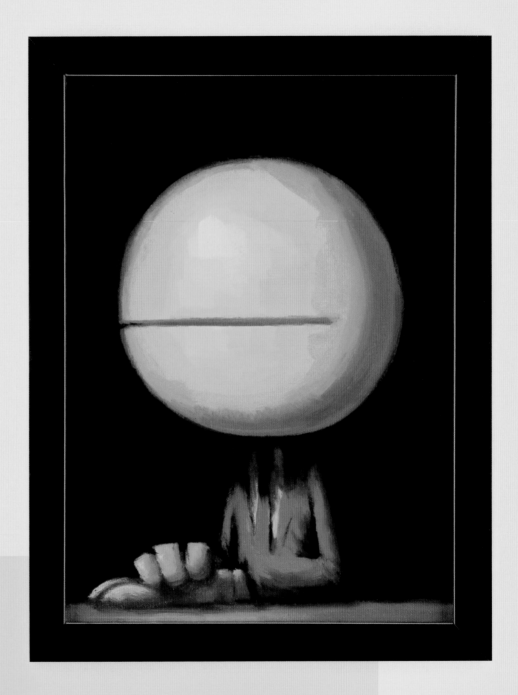

NATHAN STAPLEY
Pac-Man Portrait #2
oil on panel — 5 x 7 inches
inspiration: **Pac-Man** (arcade)

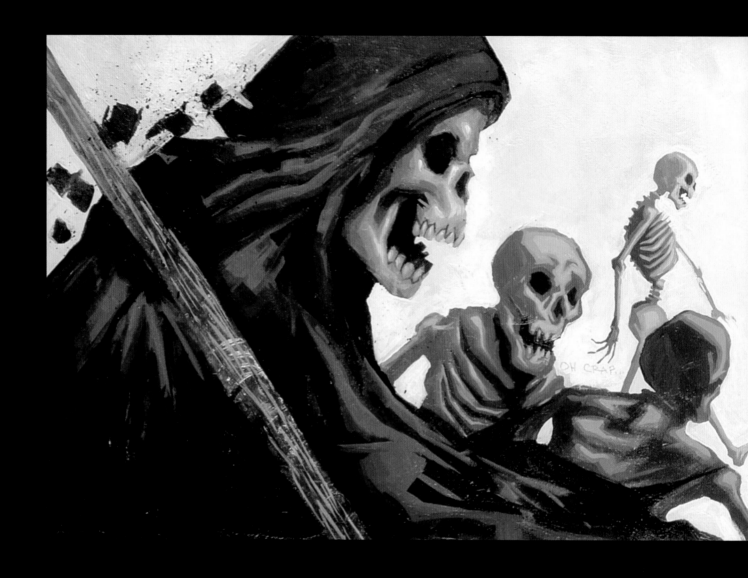

RON VELASCO
Castlevania
mixed media — 36 x 12 inches
inspiration: **Castlevania** (NES)

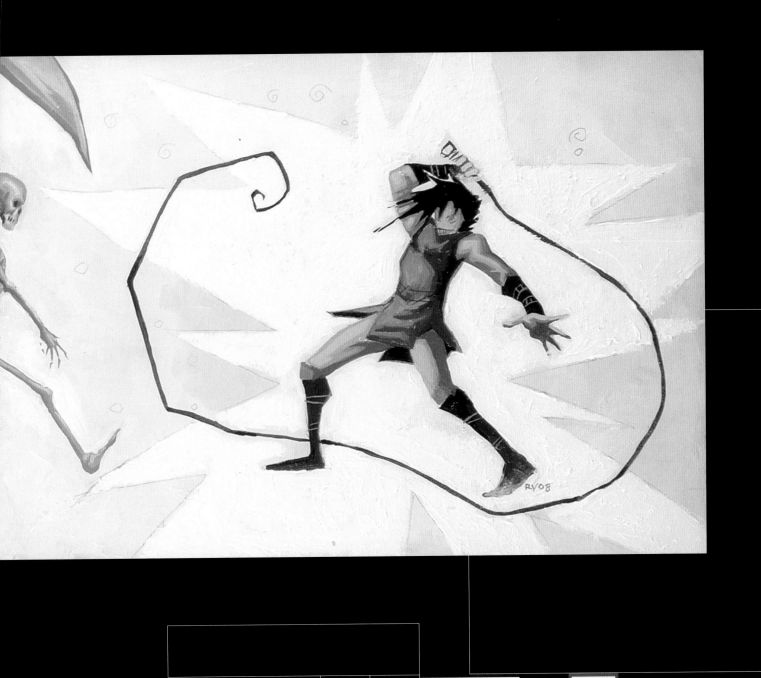

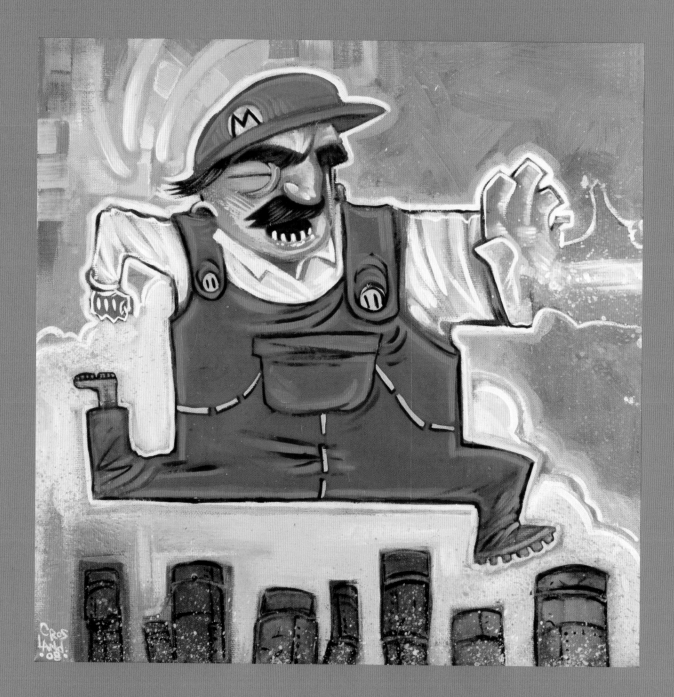

DAVE CROSLAND
Super
mixed media — 12 x 12 inches
inspiration: **Super Mario Bros.** (NES)

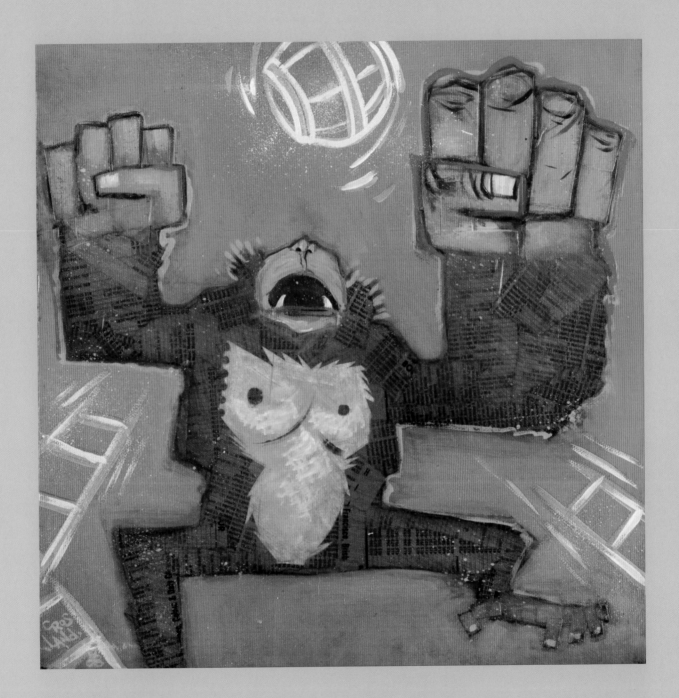

DAVE CROSLAND
Kong
mixed media — 12 x 12 inches
inspiration: **Donkey Kong** (arcade)

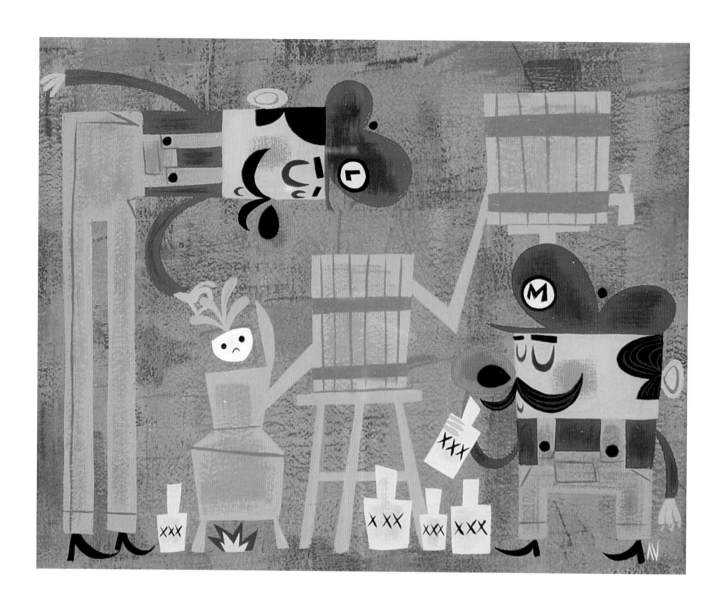

AMANDA VISELL
Mario's Moonshine Shack
acrylic on board — 17 x 14 inches
inspiration: **Super Mario Bros. 2** (NES)

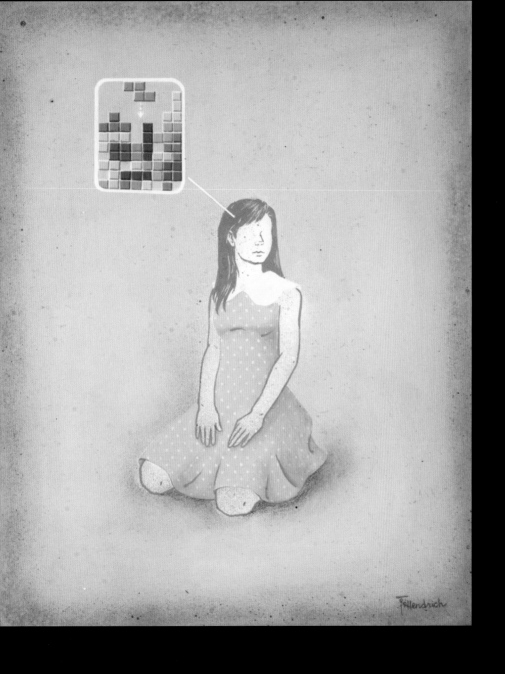

TERI HENDRICH
Mind Block
acrylic on wood panel — 7 x 9 inches

I was raised in a very religious household,
but lost my faith at a young age.
I guess you could say that

VIDEOGAMES BECAME MY RELIGION:

Nintendo was my denomination
and the Konami code my path to eternal life —
or at least 30 of them.

– Jude Buffum

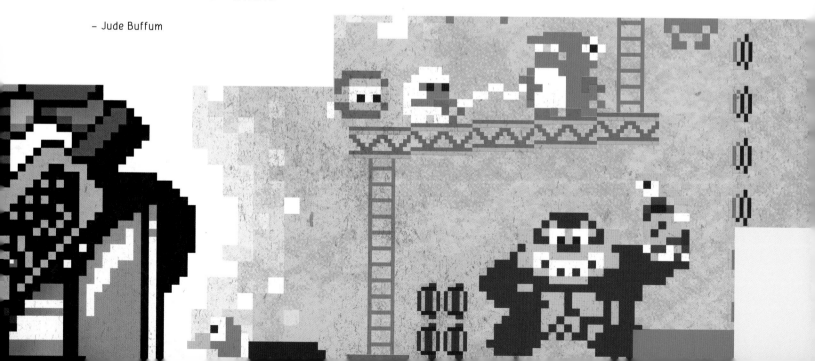

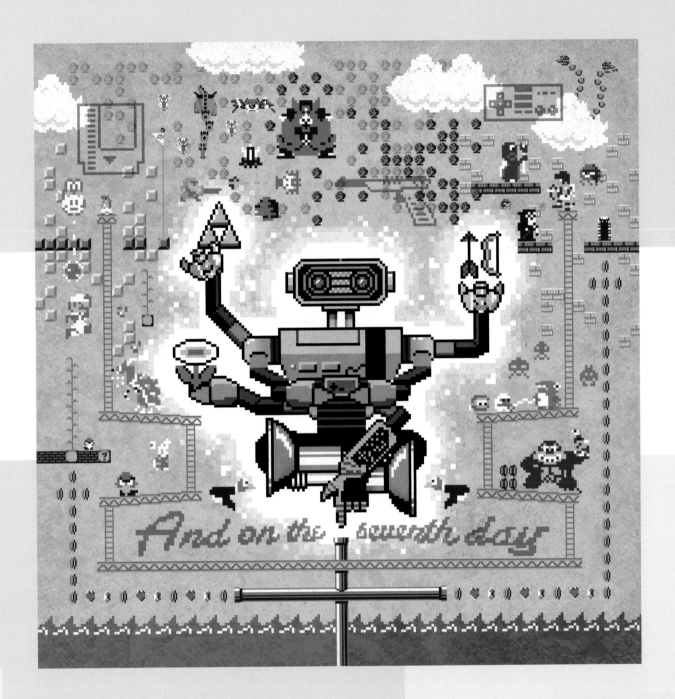

JUDE BUFFUM
And on the Seventh Day, R.O.B Rested
digital illustration on canvas — 20 x 20 inches
inspiration: **Dig Dug**, **Donkey Kong**, **Joust** (arcade); **Duck Hunt**, **Kid Icarus**, **The Legend of Zelda**, **Super Mario Bros.** (NES)

MARTIN CENDREDA
Death of an Egg
watercolor and ink on bristol board — 7 x 5 inches
inspiration: **Burgertime** (arcade)

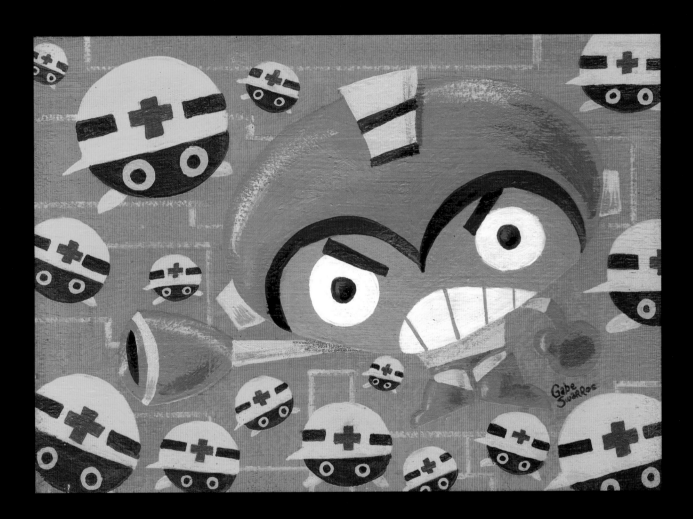

GABE SWARR
Met Attack
acrylic on board — 7¾ x 5¾ inches
inspiration: **Mega Man** (NES)

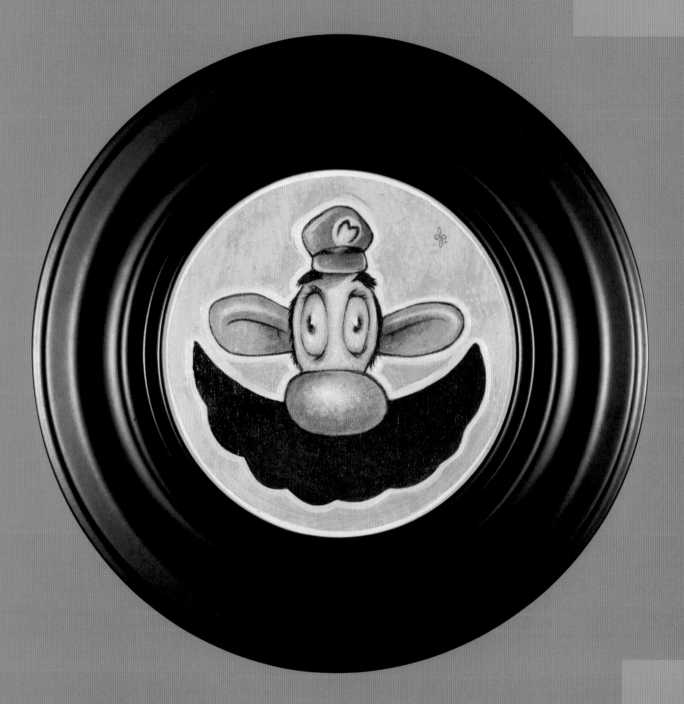

DANIEL PEACOCK
St. Mario
acrylic on canvas — 7 inches round
inspiration: Super Mario Bros. (NES)

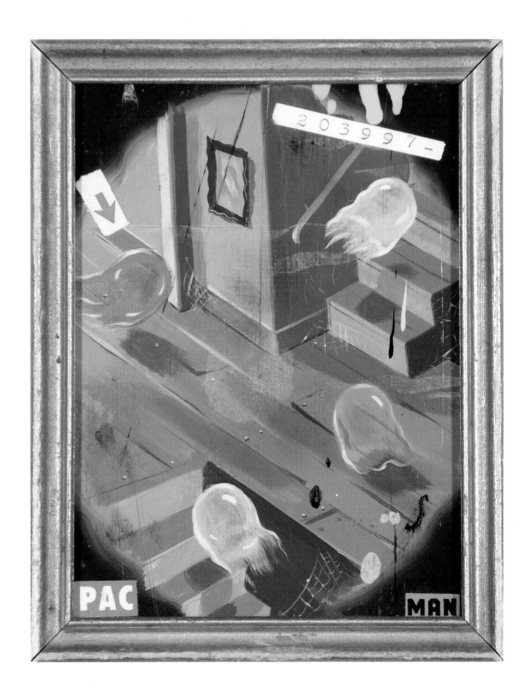

RYAN HESHKA
Ectopacman
acrylic and mixed media on board — 4 x 5 inches
inspiration: **Pac-Man** (arcade)

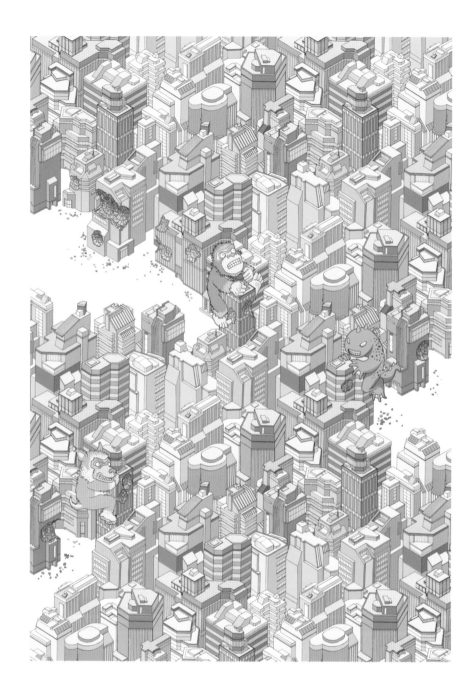

SETH FISHER
Untitled
digital illustration — 18 x 24 inches
inspiration: **Rampage** (arcade); **SimCity** (PC)

Seth was one of the most surprising and exciting artists
I've ever run into. He was a true original, absolutely

UNIQUE AND
INSPIRING.

It was a great loss to all the arts that his mind left this planet
tragically and before it was time. I think of him often and mourn
all of the lost creatures and ideas he would've slapped and tickled us
with if he was still with us.

– Darren Aronofsky

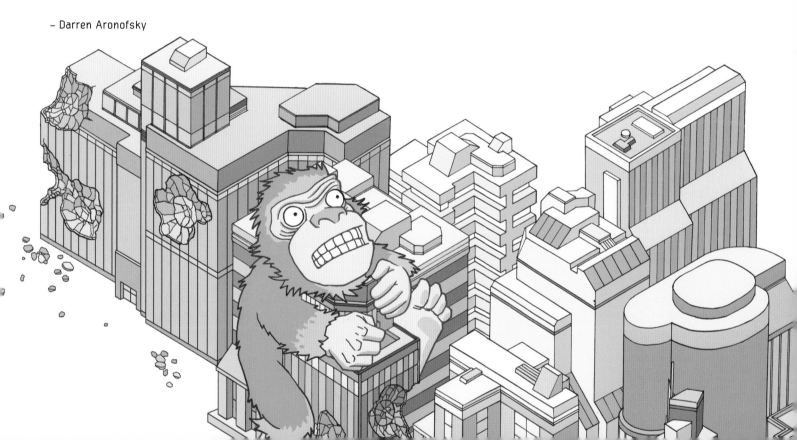

82000

SHAWNIMALS
Great 'Staches from Videogame History: Mario
plush mounted on elm — 10 x 8 x 5 inches
inspiration: **Super Mario Bros.** (NES)

SHAWNIMALS
Great 'Staches from Videogame History: Wario, Dr. Robotnik, Soda Popinski, Dr. Wily
plush mounted on elm — 10 x 8 x 5 inches each

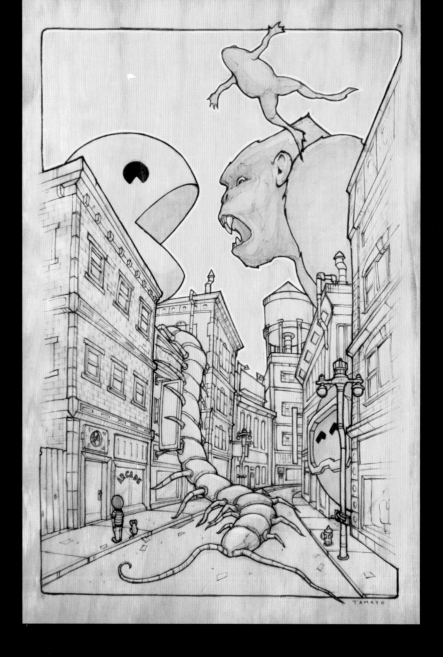

ROLAND TAMAYO

Battle for My Affection

ink, colored pencil, acrylic on wood panel — 11¾ x 17 inches

inspiration: **Centipede, Dig Dug, Donkey Kong, Frogger, Pac-Man** (arcade)

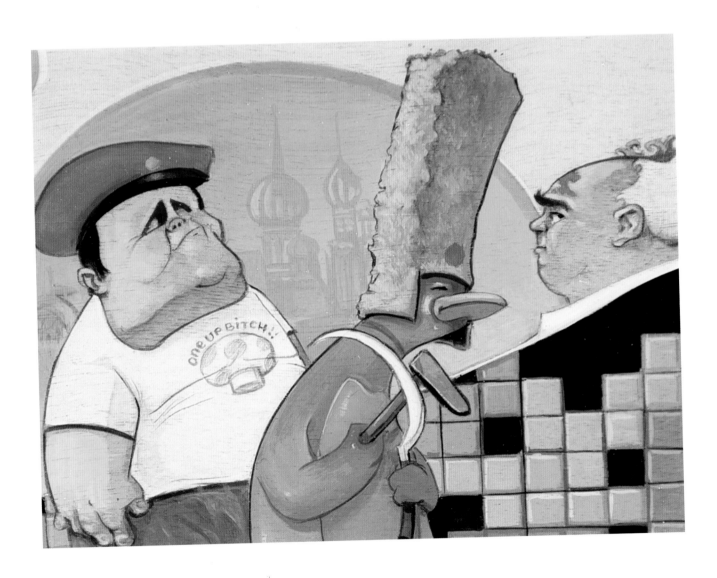

JOPHEN STEIN
The Guardian Angle: White Russian Attack '89
acrylic on board — 12 x 10 inches
inspiration: **Tetris** (NES)

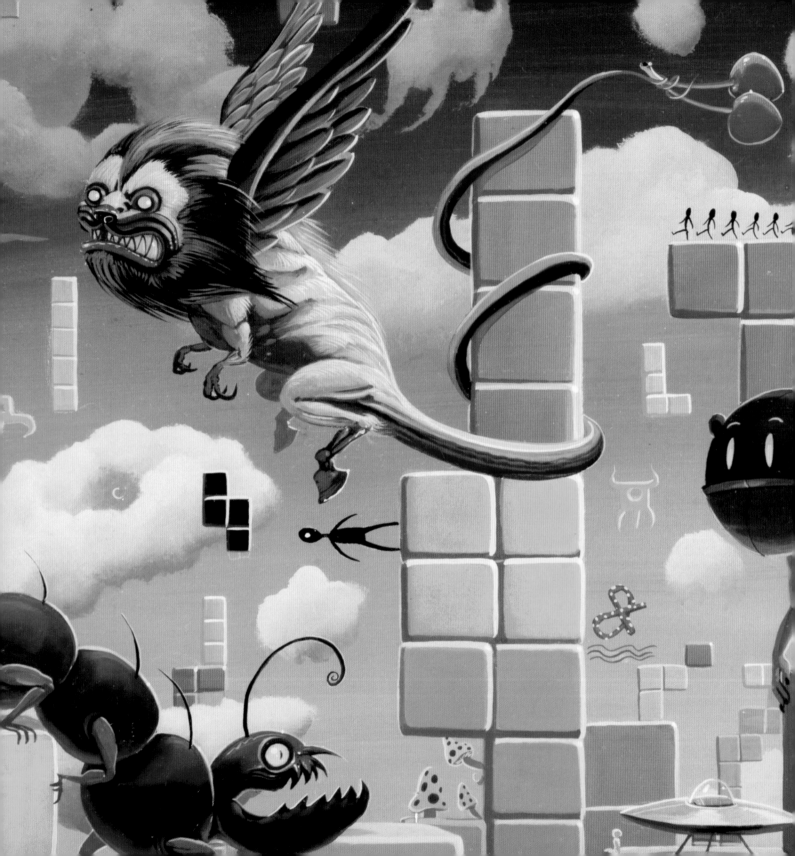

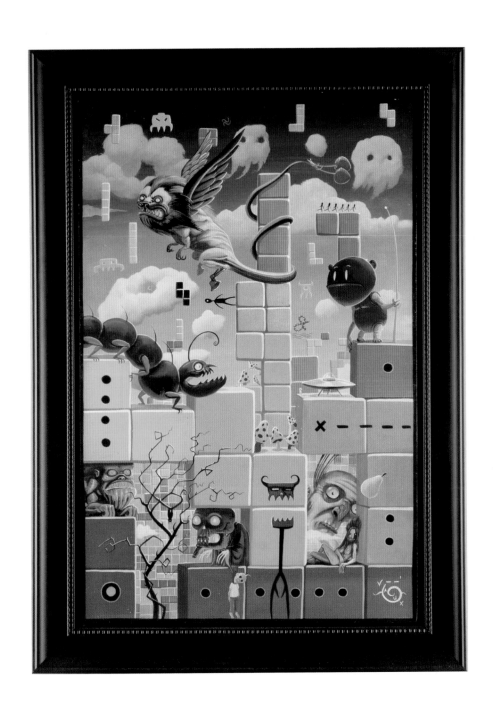

JOE VAUX
Reset
acrylic on wood panel — 16 x 24 inches
inspiration: **Centipede, Dig Dug, Pac-Man, Space Invaders** (arcade); **Super Mario Bros., Tetris** (NES)

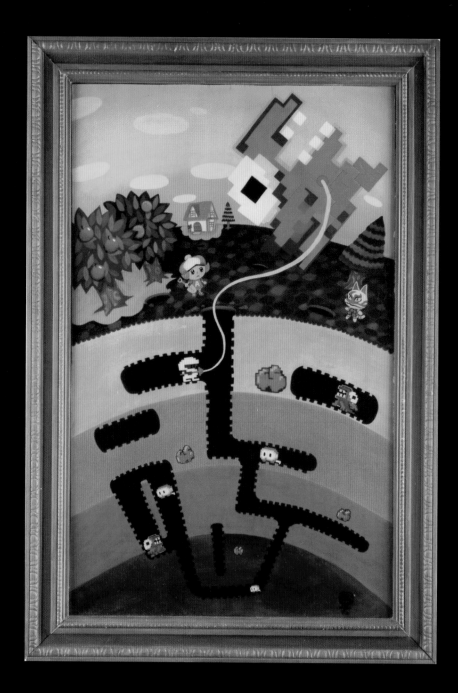

DEE CHAVEZ
Crossing Over
acrylic on oak panel with handmade frame — 18 x 26 inches
inspiration: **Dig Dug** (arcade)

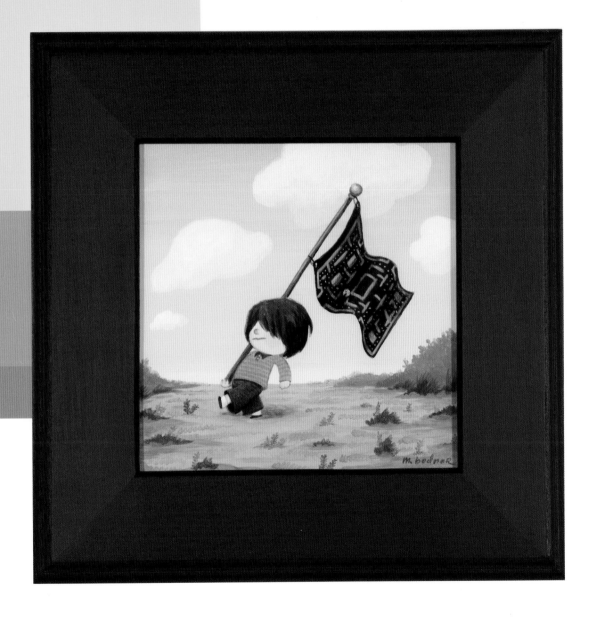

MARK BODNAR
And I'll Do It Again
acrylic on board — 7 x 7 inches
inspiration: **Ms. Pac-Man** (arcade)

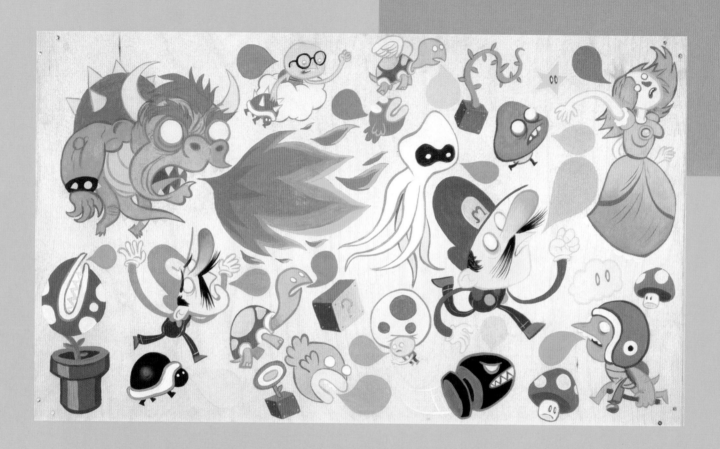

JEREMY TINDER
Vs. Super Mario Bros.
acrylic on wood — 20 x 12 inches
inspiration: **Super Mario Bros.** series

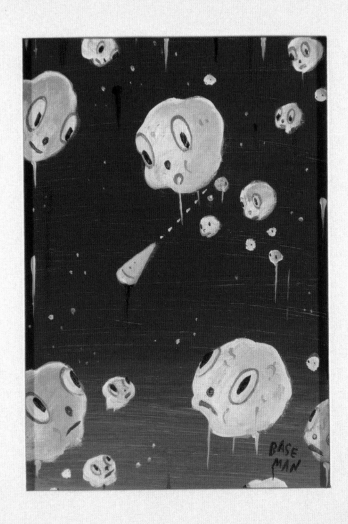

GARY BASEMAN
Asteroids
acrylic on board — 8 x 10 inches
inspiration: Asteroids (arcade)

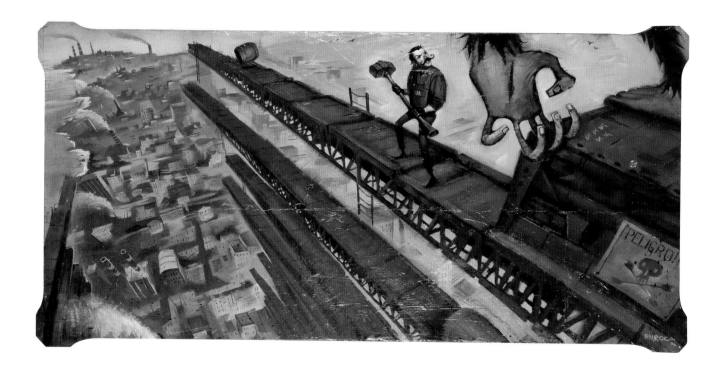

JOSE EMROCA FLORES
I Thought I Came to Plumb
oil on board — 39 × 19 inches
inspiration: **Donkey Kong** (arcade)

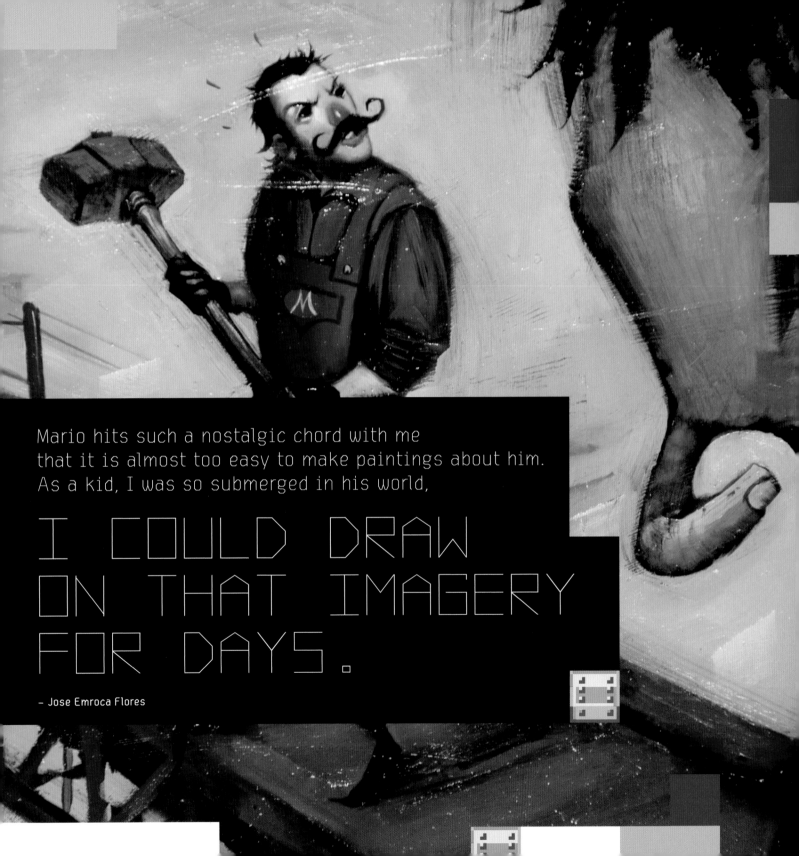

Mario hits such a nostalgic chord with me
that it is almost too easy to make paintings about him.
As a kid, I was so submerged in his world,

I COULD DRAW
ON THAT IMAGERY
FOR DAYS.

– Jose Emroca Flores

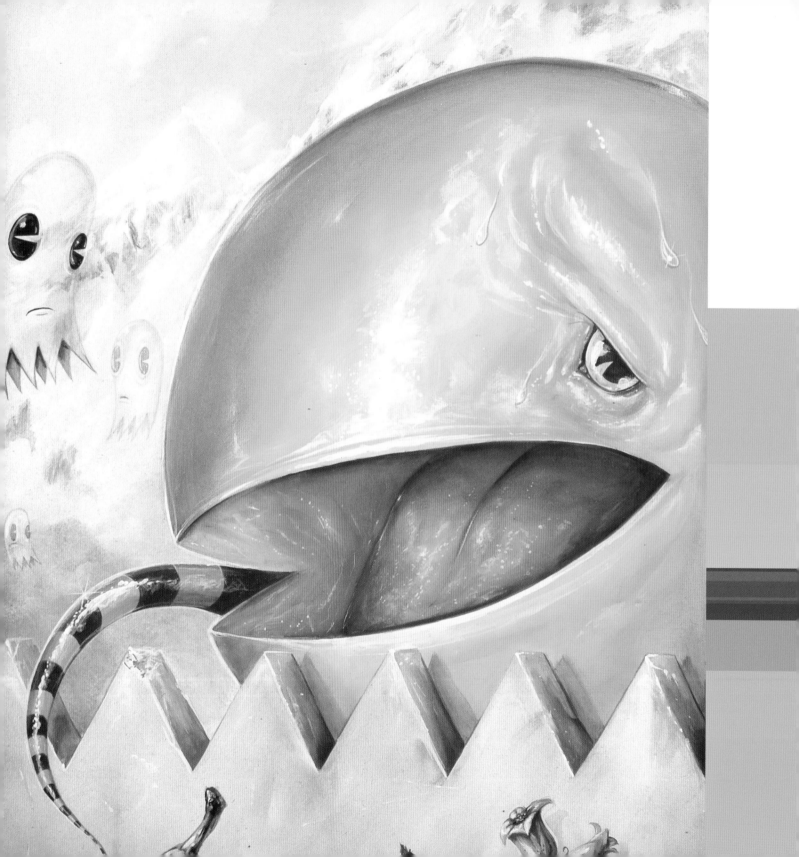

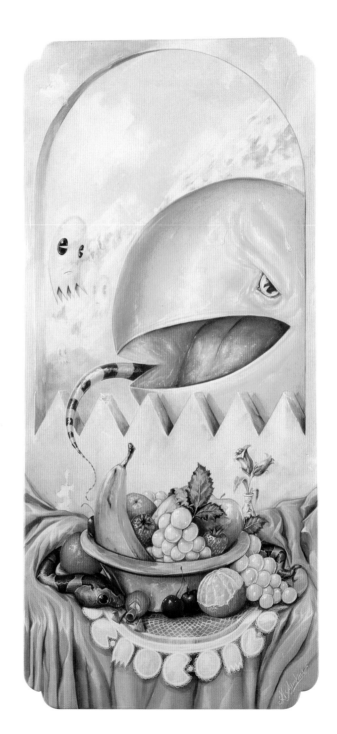

GREG "CRAOLA" SIMKINS
Forbidden Fruits
acrylic on canvas — 12 x 26 inches
inspiration: Pac-Man, Q*bert (arcade)

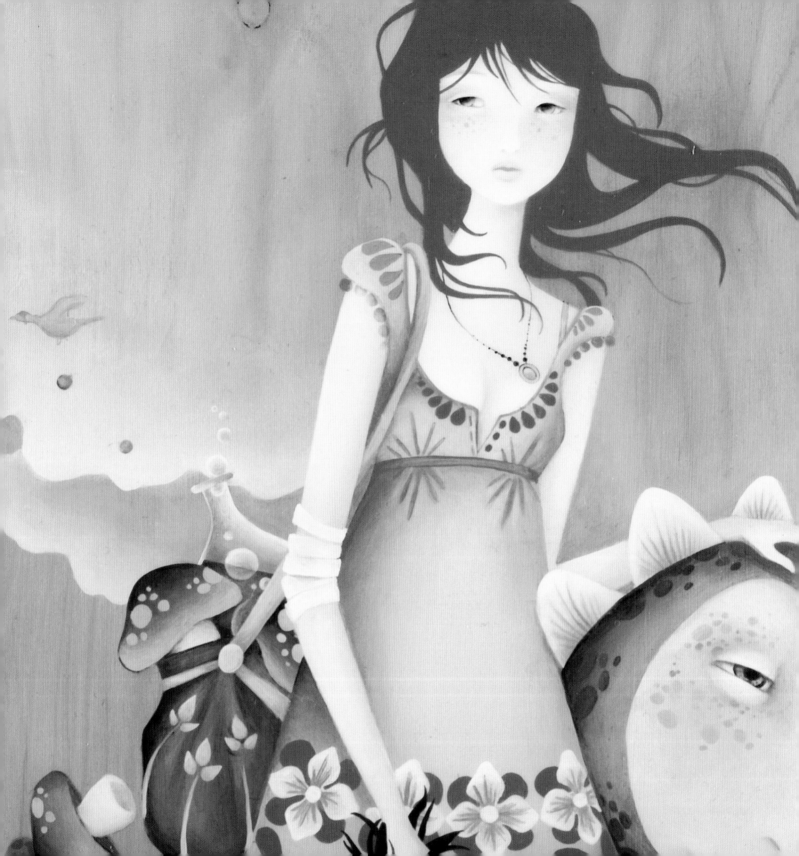

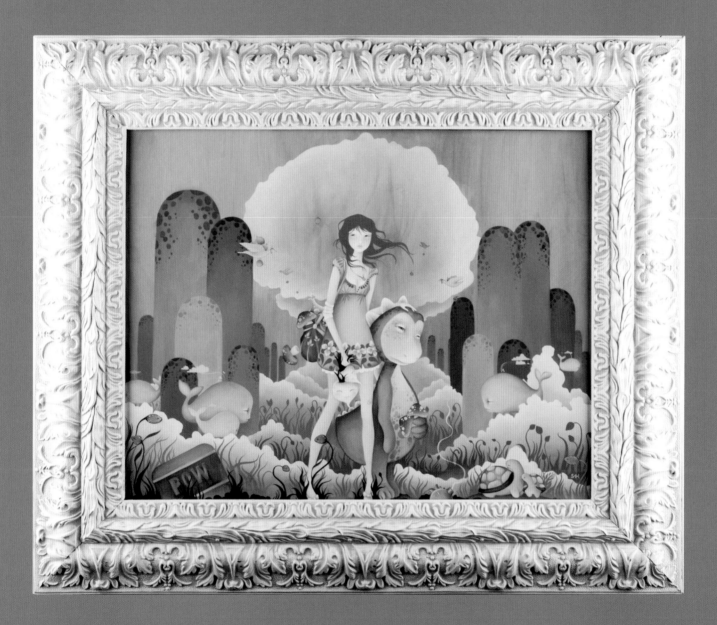

AMY SOL
Peach & Yoshi in Subcon, the Land of Dreams
acrylic on wood panel — 22 x 17 inches
inspiration: **Super Mario World** (SNES)

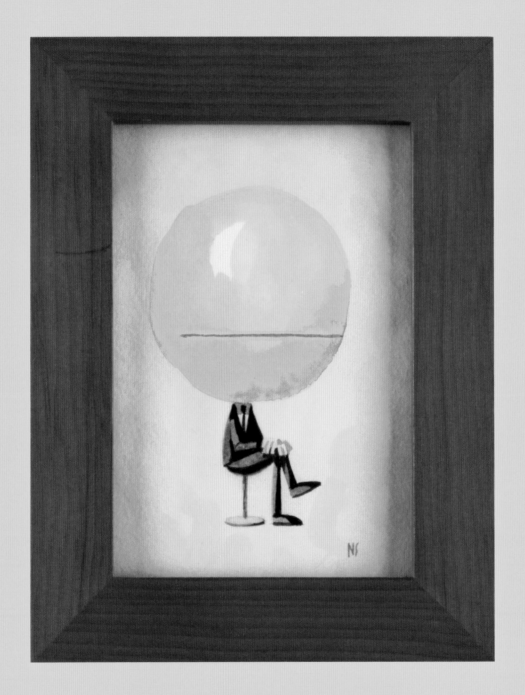

NATHAN STAPLEY
Pac-Man Portrait #4
watercolor on paper — 3½ x 5 inches
inspiration: **Pac-Man** (arcade)

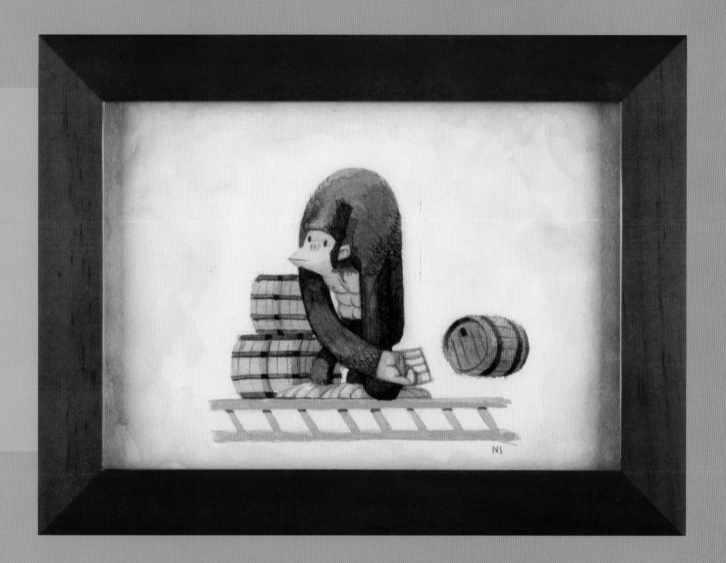

NATHAN STAPLEY
Kong: Throwing Barrels
watercolor on paper — 6 x 4 inches
inspiration: **Donkey Kong** (arcade)

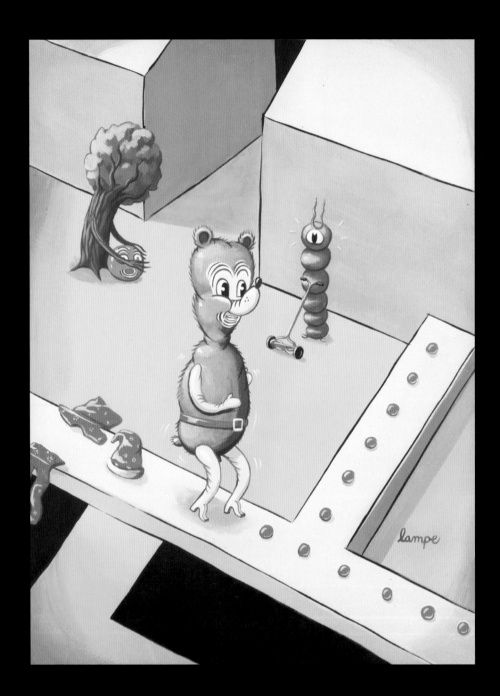

TRAVIS LAMPE
Bentley Bare
acrylic on wood panel — 8¾ x 11¾ inches
inspiration: **Crystal Castles** (arcade)

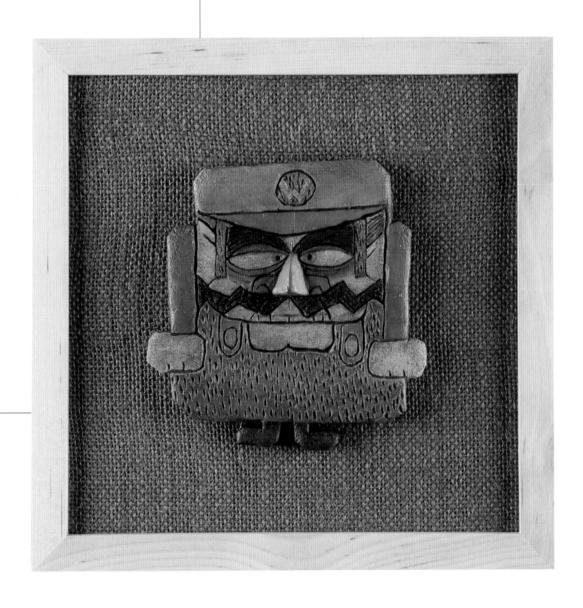

JOHNNY YANOK
Wario
clay mounted on burlap board — 8½ x 8½ inches
inspiration: **Wario's Woods** (NES)

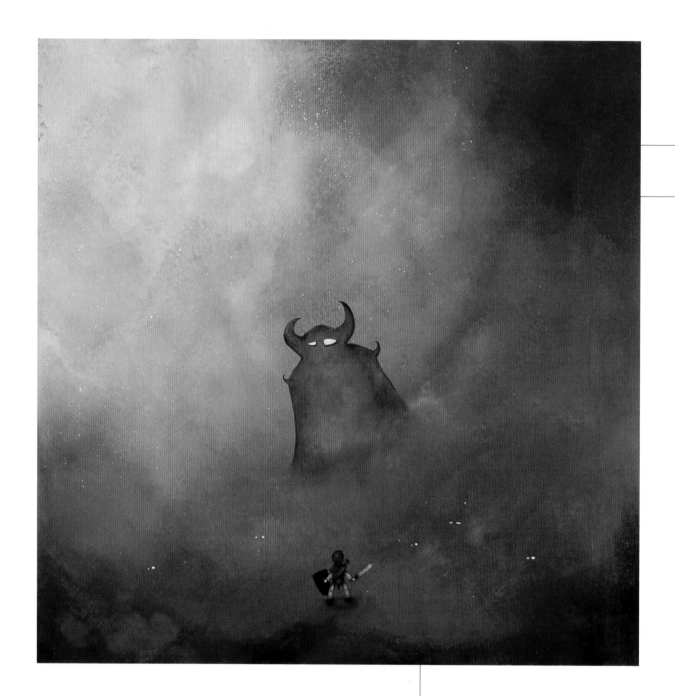

SCOTT BELCASTRO
Link vs. Ganon
acrylic on panel — 24 x 24 inches
inspiration: The Legend of Zelda (NES)

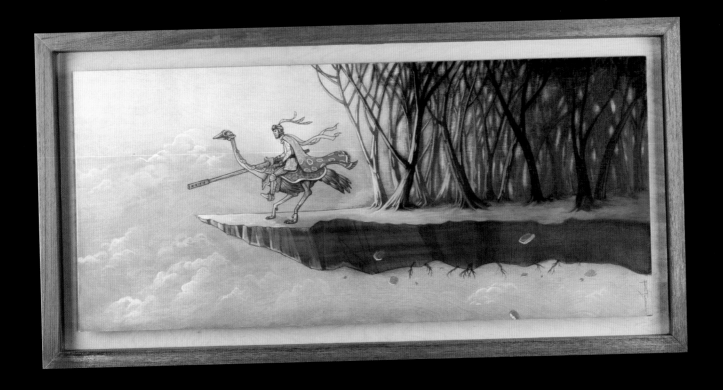

RICH TUZON
Joust V.1.0 Morning Flight
acrylic on wood panel — 33½ x 17 inches
inspiration: **Joust** (arcade)

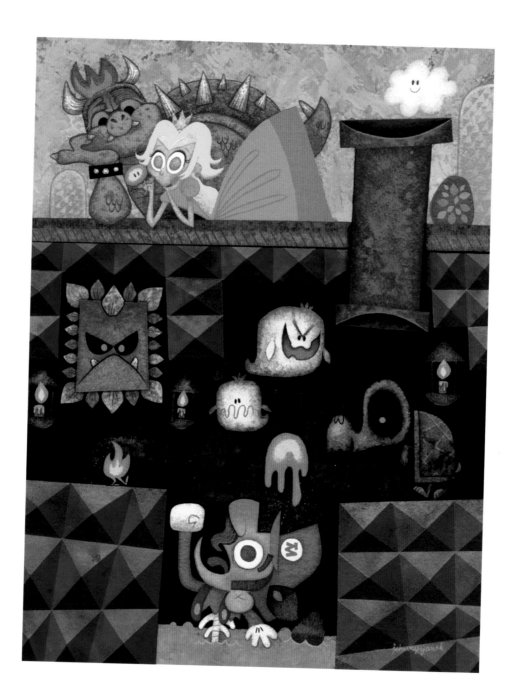

JOHNNY YANOK
This Game Cheats!
gouache on watercolor paper — 11½ x 15½ inches
inspiration: **Super Mario Bros. 3** (NES)

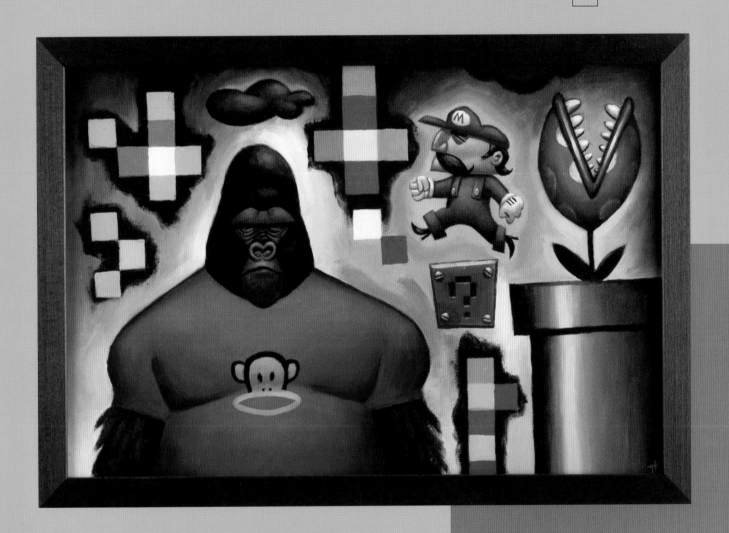

THORSTEN HASENKAMM
8-bit Icons
acrylic on masonite — 16 x 11 inches
inspiration: **Donkey Kong** (arcade); **Super Mario Bros., Tetris** (NES)

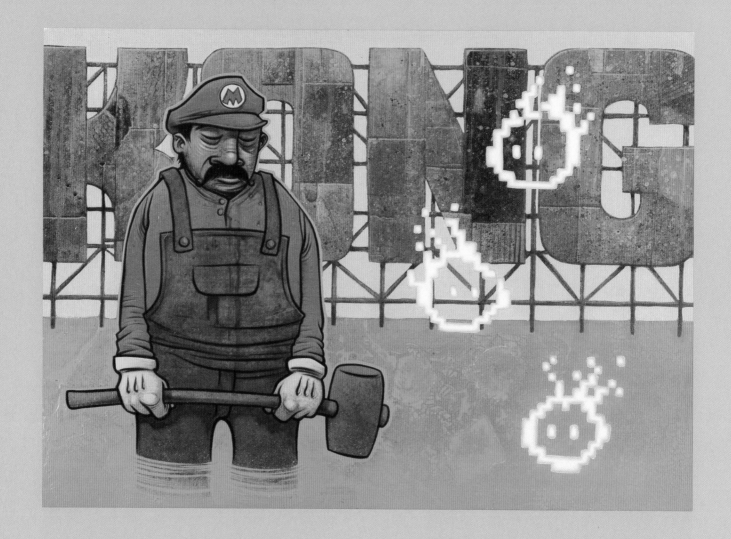

REUBEN RUDE
Mario's Lament
collage and acrylic on board — 16½ x 11½ inches
inspiration: **Donkey Kong** (arcade)

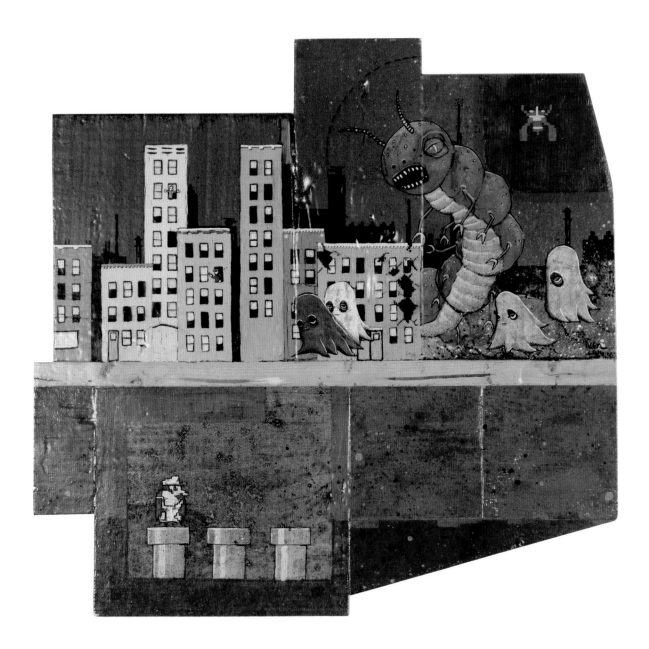

DENNIS HAYES IV
Avoiding Rampage
acrylic on board — 14½ x 14½ x 1¾ inches
inspiration: **Centipede, Galaga, Pac-Man, Rampage** (arcade); **Super Mario Bros.** (NES)

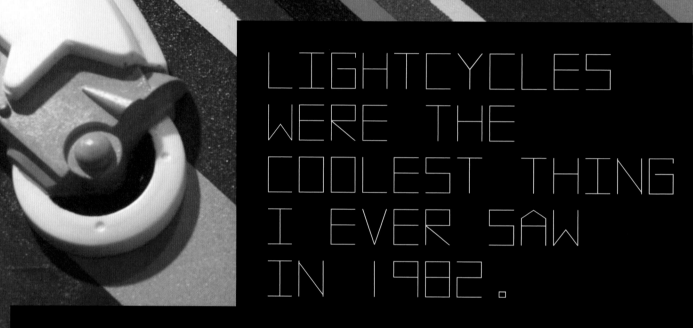

LIGHTCYCLES WERE THE COOLEST THING I EVER SAW IN 1982.

Everything about them turned me on: Syd Mead's minimalist, futuristic design; and the sounds they made when making turns and while accelerating. I wanted to take it to a new level, with a hyper-colored motif — a kind of remix. The vortex represents an abstract concept of the MCP as a definitive starting point for the piece, just like a maze. From there, it's up to the 'user' to go where they will.

– Plasticgod

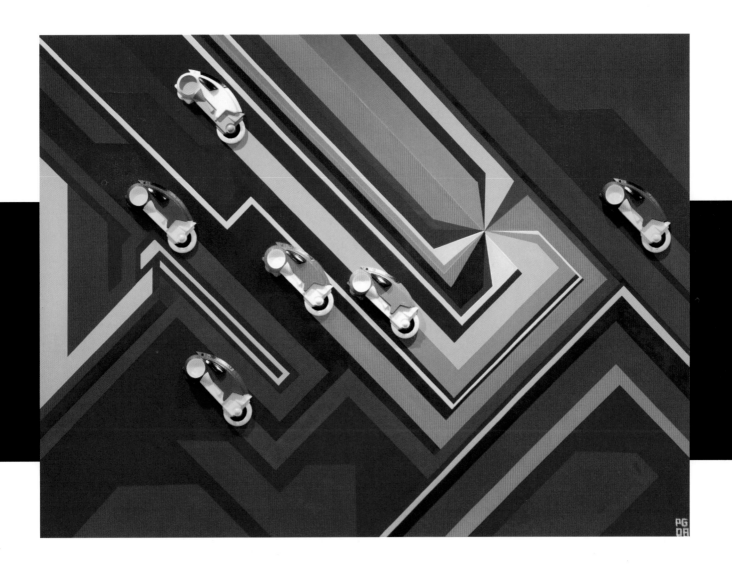

PLASTICGOD
Resolution of Light
Acrylic, resin and mixed media on wood — 48 x 36 x 5 inches
inspiration: **Tron** (arcade)

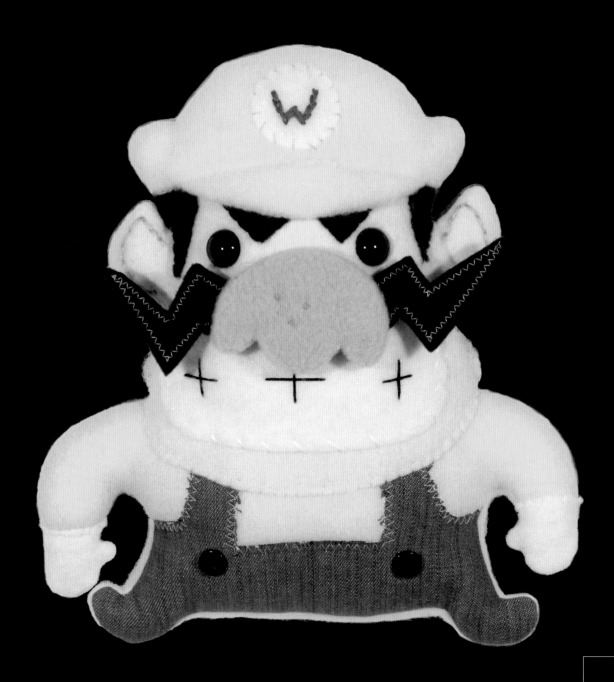

ANNA CHAMBERS
Wah Wah Wario!!!
hand-sewn plush — 9½ x 9 inches
inspiration: **Super Mario Bros.** series

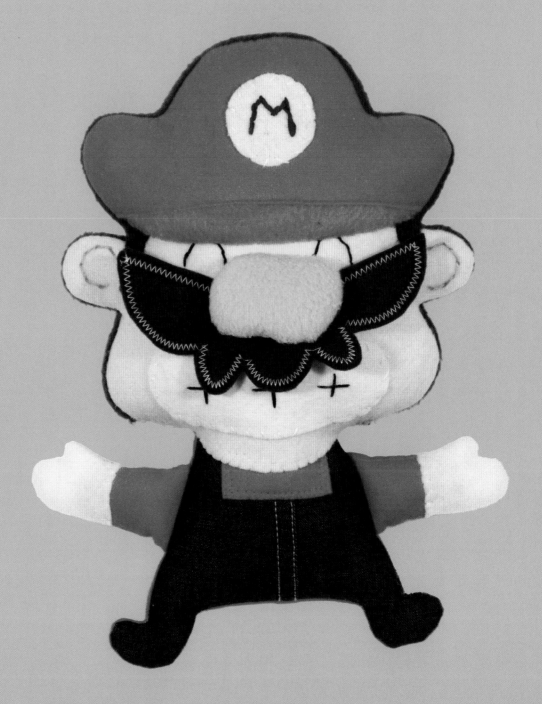

ANNA CHAMBERS
IT'S-A-ME, Mario!
hand-sewn plush — 8½ x 11 inches
inspiration: **Super Mario Bros. series**

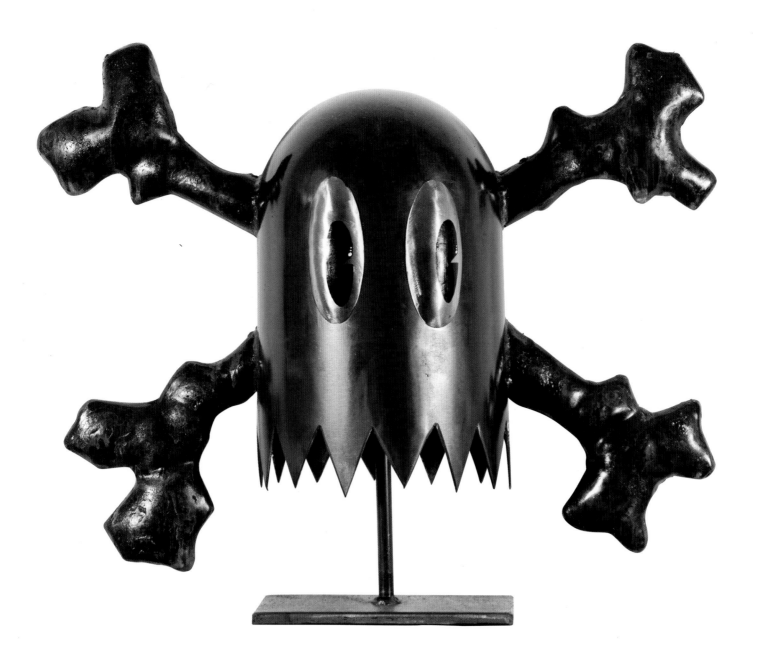

STONE
Eat Me, You Fat Yellow Bastard
steel — 29 x 18 inches
inspiration: **Pac-Man** (arcade)

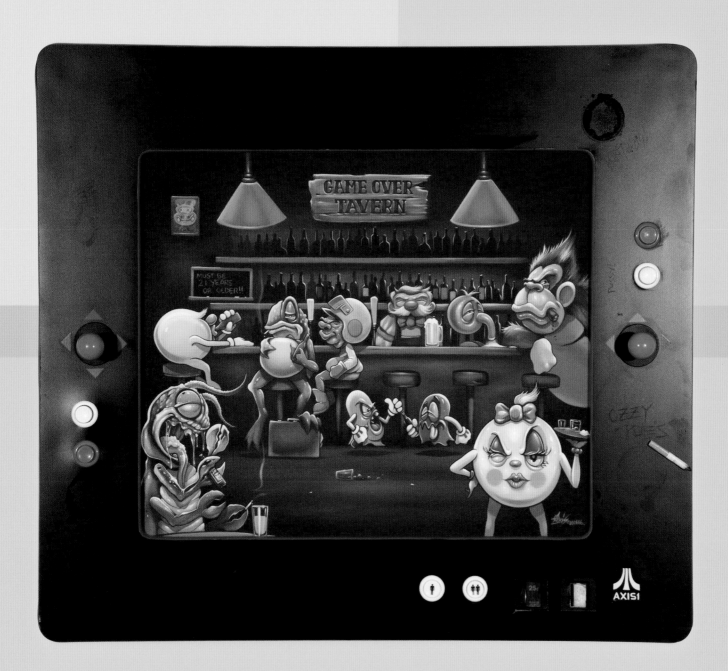

113000

AXIS
Game Over
acrylic on canvas in custom frame by Team Meltxor & Axis — 33 x 29½ inches
inspiration: **Centipede, Dig Dug, Donkey Kong, Frogger, Ms. Pac-Man, Q*bert** (arcade)

BEN BUTCHER
Fill 'er Up
mixed media — 40 x 12 inches
inspiration: **Dig Dug** (arcade)

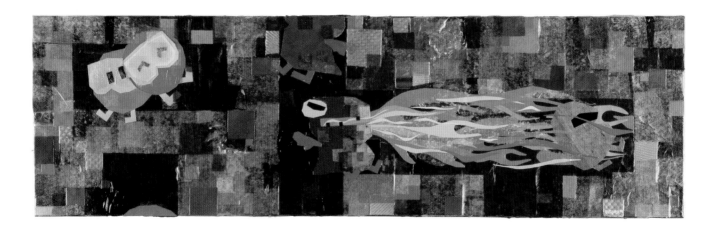

BEN BUTCHER
Fygar's Revenge
mixed media — 40 x 12 inches
inspiration: **Dig Dug** (arcade)

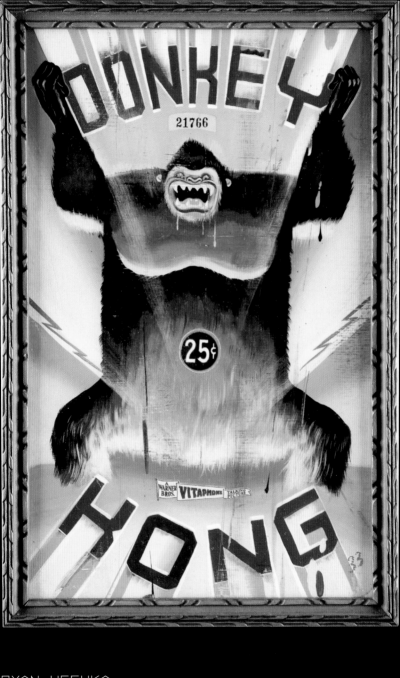

RYAN HESHKA
DONKEY KONG

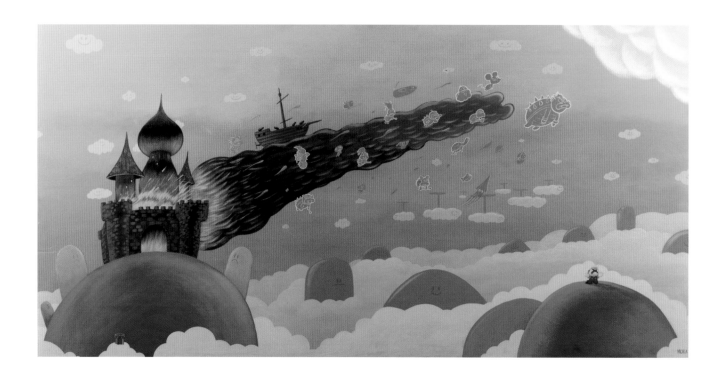

TONY MORA
With Great Power, Comes Great Responsibility
acrylic on wood — 48 x 24 inches
inspiration: **Super Mario Bros.** series

Mario 'killing' Bowser is a recurring theme
throughout almost all of the Super Mario series...

BUT WHAT IF MARIO REALLY KILLED HIM?

Oh sure, maybe he had it coming,
but Mario would have never intentionally
offed the big lug. He's silently screaming
to the big puffy cloud in the sky, asking
for forgiveness for his misplaced fireball...
or maybe he's pleading to the player to hit
the 'reset' button to do it all over again.

– Tony Mora

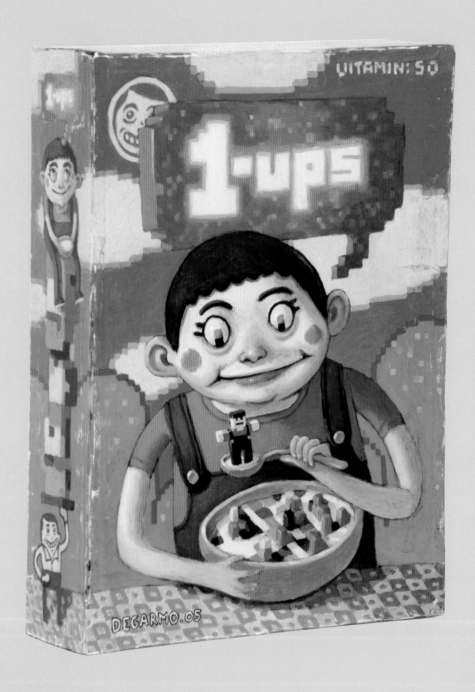

JUSTIN DEGARMO
1-Ups
acrylic on canvas — 8 x 12 x 2½ inches
inspiration: **Super Mario Bros., Tetris** (NES)

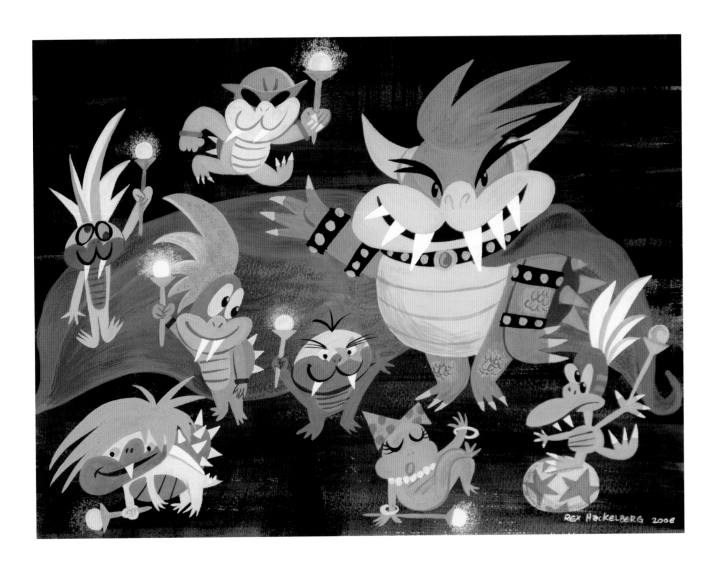

REX HACKELBERG
Koopa Royale
gouache on watercolor paper — 16 x 12 inches
inspiration: **Super Mario Bros. 3** (NES)

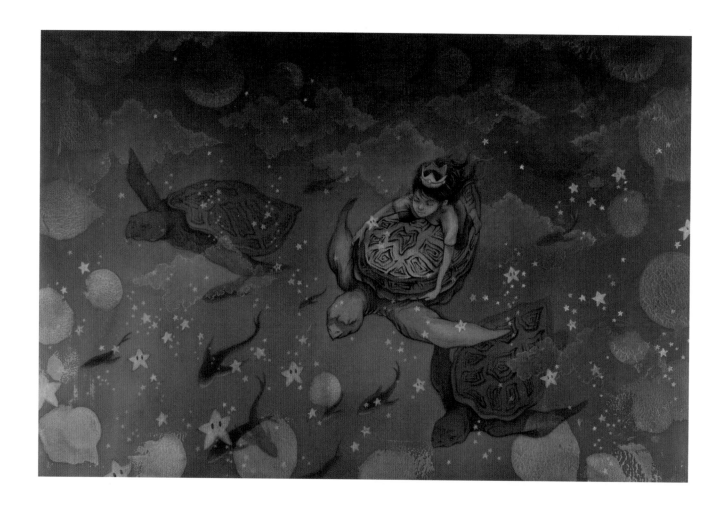

YUTA ONODA
Wish Upon a Star
mixed media — 24 x 16 inches
inspiration: **Super Mario Bros.** (NES)

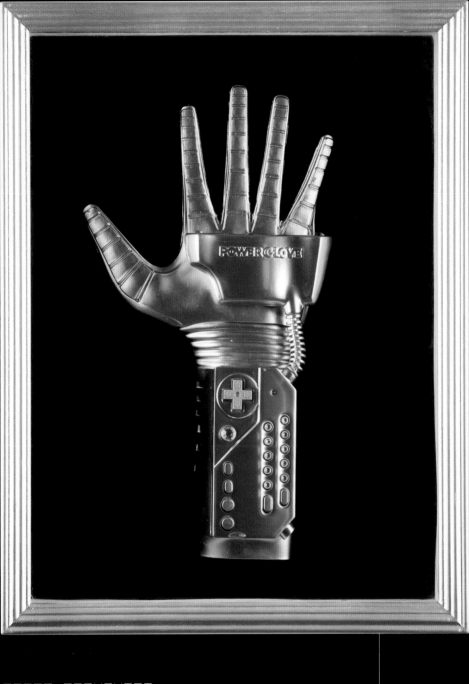

PETER GRONQUIST
The Glove of Power

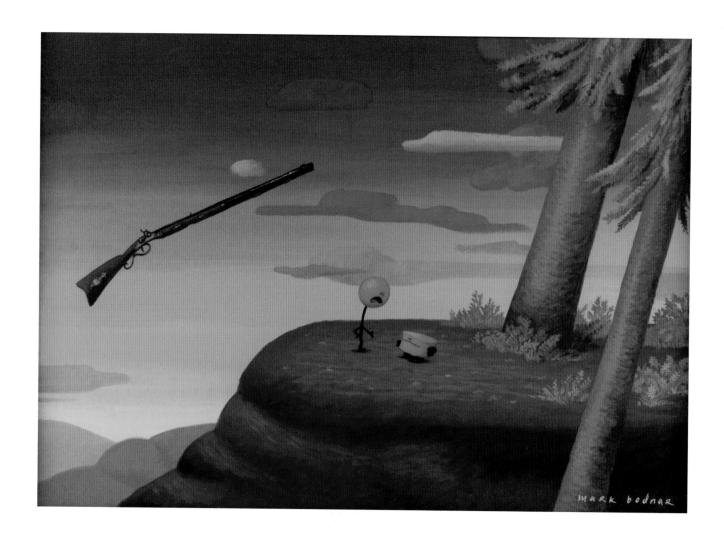

MARK BODNAR
Joystick and Button Contemplated a Rifle and Were Reassured of Their Retirement
acrylic on canvas — 23 x 30 inches
inspiration: arcades

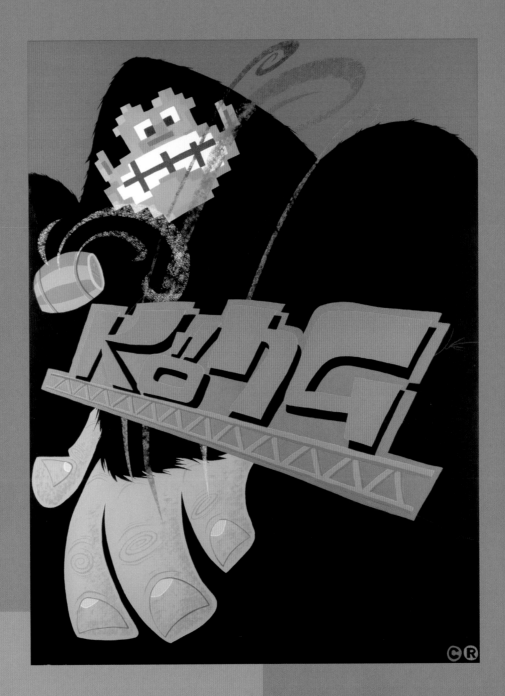

CARLOS RAMOS
KONG!
cel vinyl on wood — 36 x 48 inches
inspiration: **Donkey Kong** (arcade)

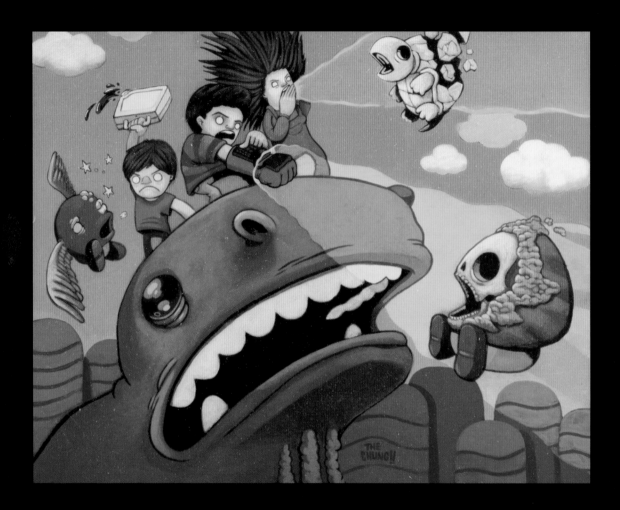

THE CHUNG!!
The Wizard
acrylic on canvas — 14 x 11 inches
inspiration: **The Wizard** (VHS)

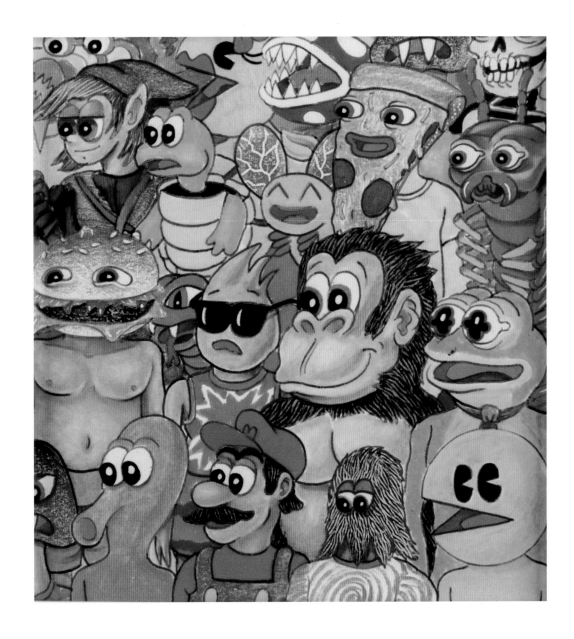

MATT FURIE
Ninfriendos
ink and colored pencil on matboard — 6½ x 7 inches
inspiration: Centipede, Donkey Kong, Frogger, Ms. Pac-Man, Q*Bert (arcade); The Legend of Zelda, Super Mario Bros. (NES)

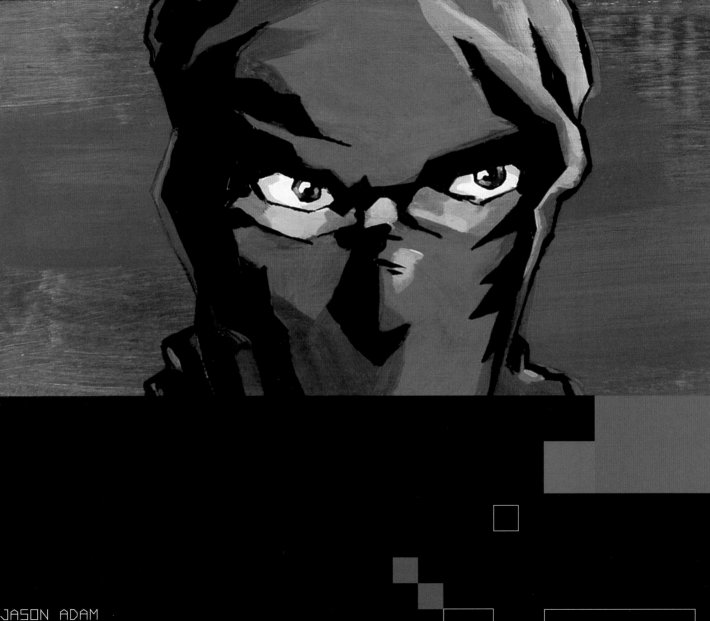

JASON ADAM

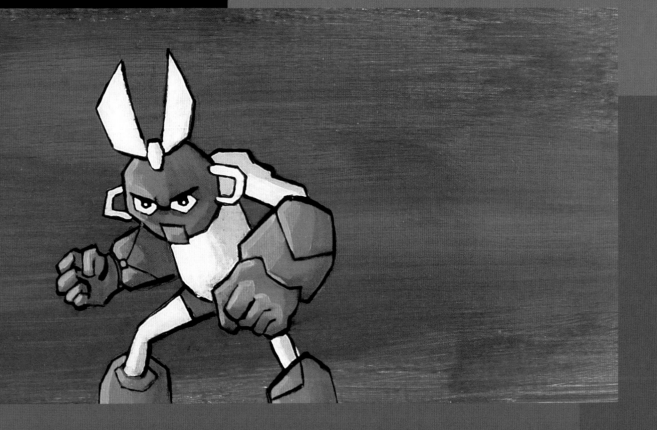

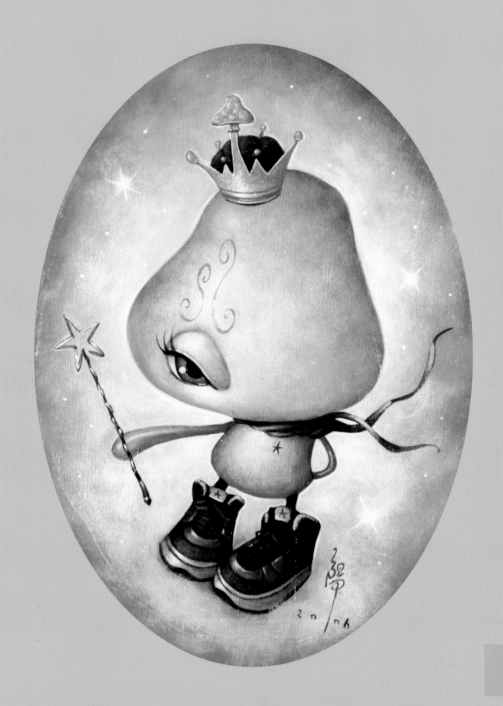

YOSUKE UENO
King of the Underdog
acrylic on wood — 7 x 9½ inches
inspiration: **Super Mario Bros.** (NES)

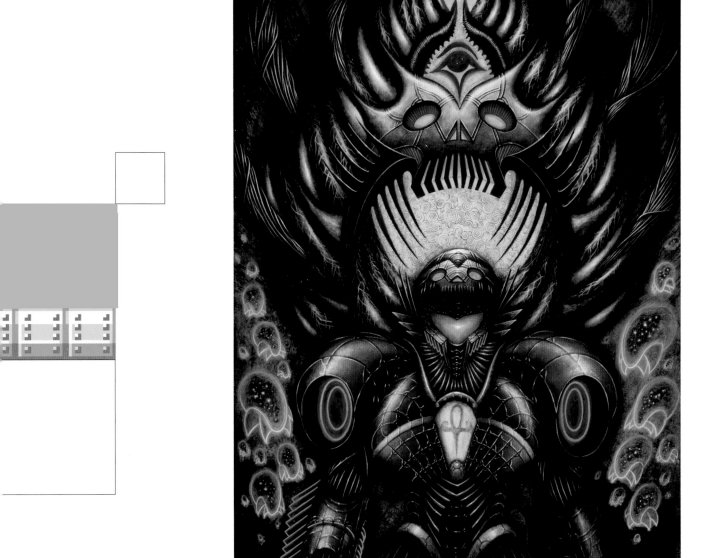

ERIK SIADOR
Psycho Babble
acrylic on paper on wood — 15½ x 20¼ inches
inspiration: Metroid (NES)

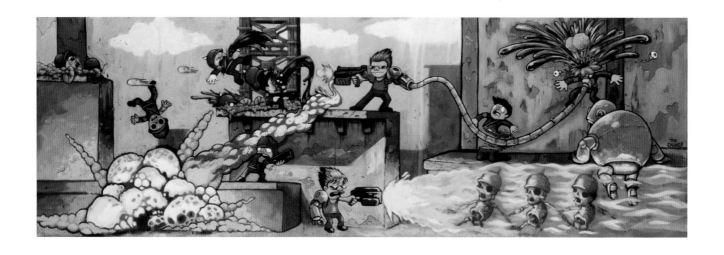

THE CHUNG!!
Level 1: PWN'D!
acrylic on canvas — 36 x 12 inches
inspiration: **Bionic Commando** (NES)

Bionic Commando was just a cool-ass game!
You were literally fighting Nazis and killing Hitler.
But the fact that you had a robotic arm that could shoot out
and act as a grappling hook...

THAT'S FUCKING COOL!

– The Chung!!

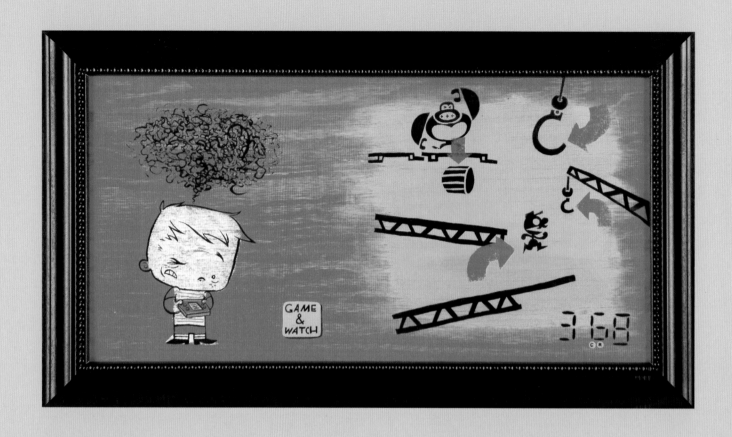

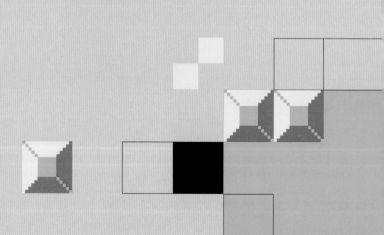

CARLOS RAMOS
Shame N' Watch
acrylic on wood — 20 x 10 inches
inspiration: **Donkey Kong** (Game & Watch)

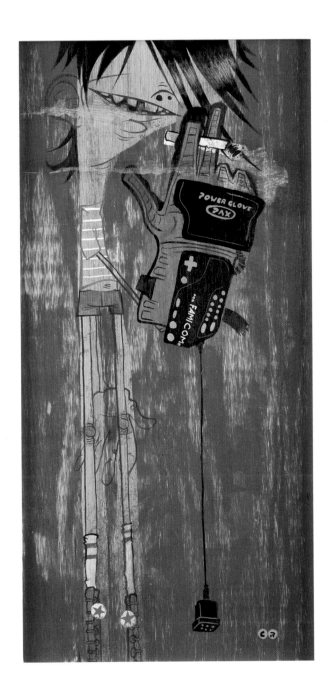

CARLOS RAMOS
Power Love
acrylic on wood — 10 x 20 inches
inspiration: Nintendo Entertainment System

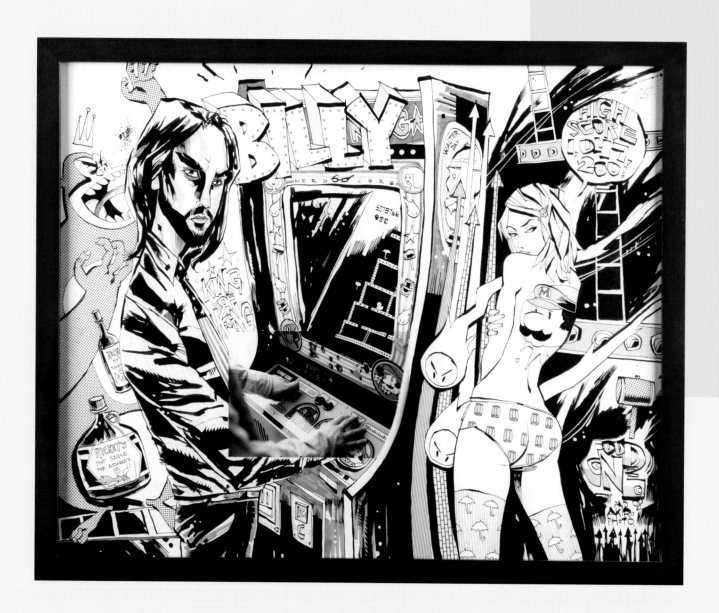

JIM MAHFOOD
Billy
ink, paint, Zip-A-Tone & photo print on paper — 21 x 17 inches
inspiration: **The King of Kong: A Fistful of Quarters**

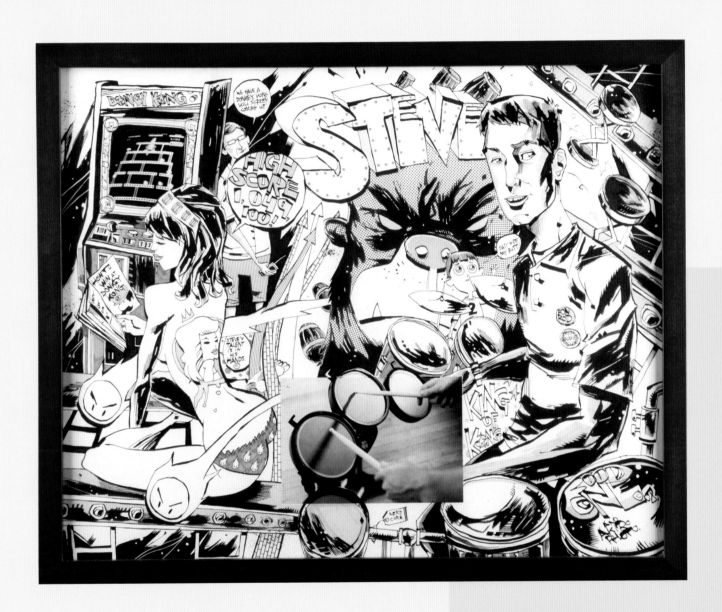

JIM MAHFOOD
Steve
ink, paint, Zip-A-Tone & photo print on paper — 21 x 17 inches
inspiration: **The King of Kong: A Fistful of Quarters**

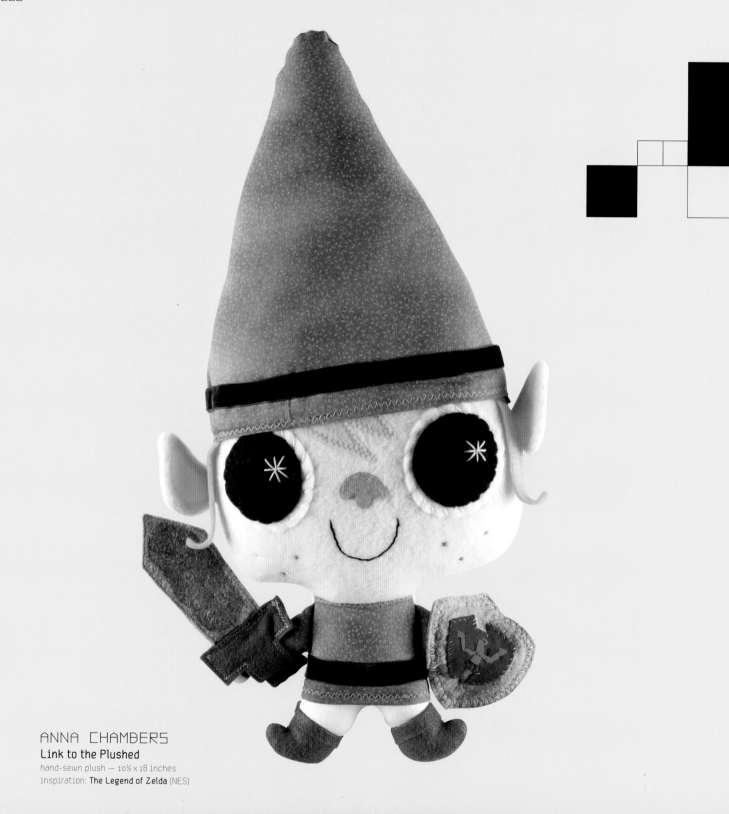

ANNA CHAMBERS
Link to the Plushed
hand-sewn plush — 10½ x 18 inches
inspiration: **The Legend of Zelda** (NES)

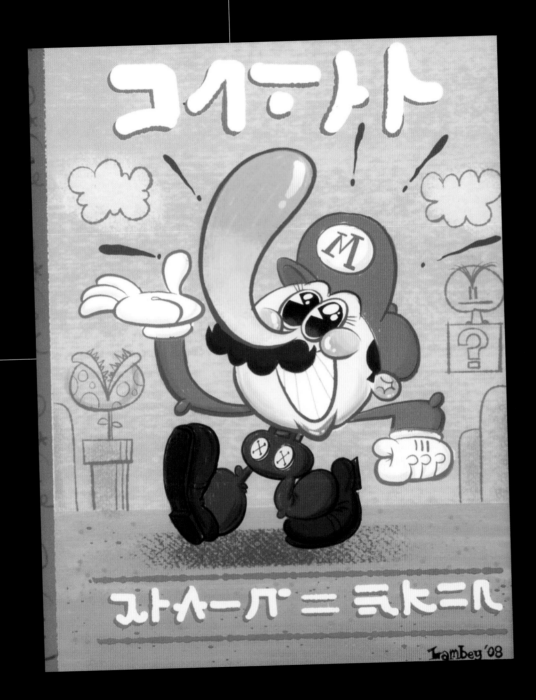

STEVE LAMBE
Super Mario-San
cel vinyl on velvet fine art paper — 11 x 14 inches
inspiration: **Super Mario Bros.** (NES)

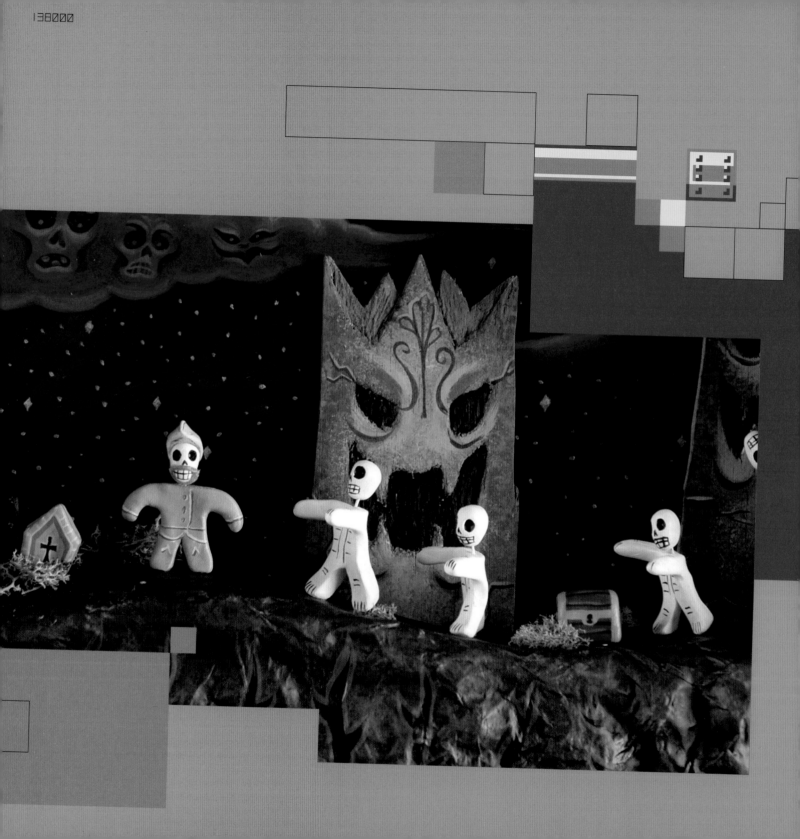

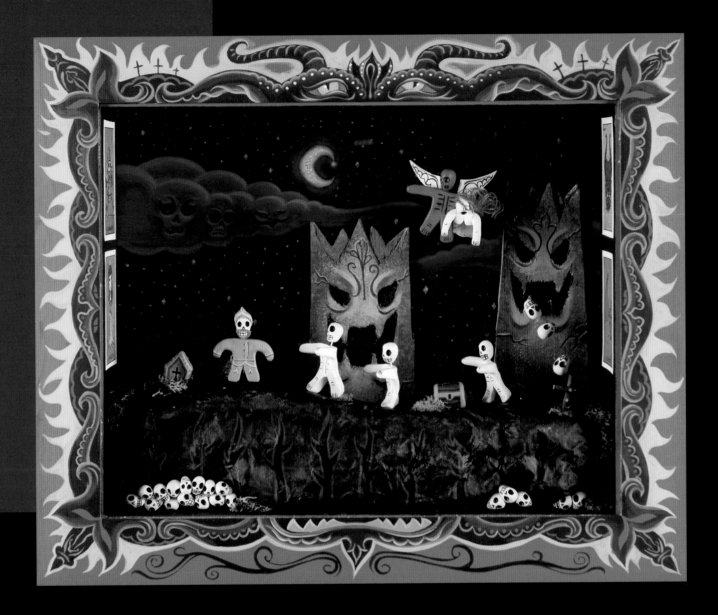

SEÑOR CHIPS & GERALD DE JESUS
Fantasmas y Goblins
mixed media diorama — 17 x 14 inches
inspiration: **Ghosts 'n Goblins** (NES)

TWO-PLAYER SIDE-SCROLLERS ARE JUST FUN AS HELL.

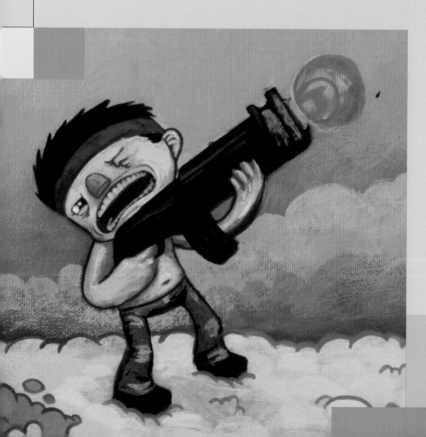

My brother and I used to play Contra all the time. It took us forever to pass just one level due to the fact that we would always try to kill each other by advancing ahead, forcing us to fall off the screen and die. We'd roll on the floor, laughing our asses off because we both knew there's just no way we'd be able to cooperate enough to pass a single level.

– The Chung!!

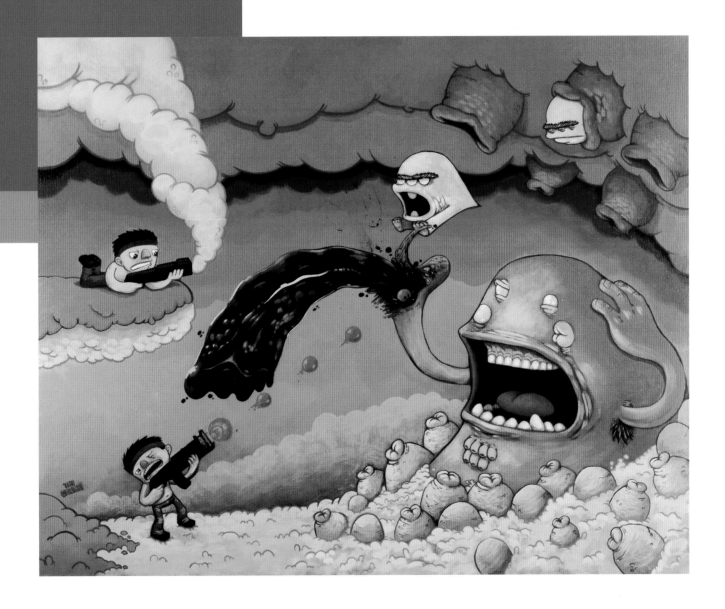

THE CHUNG!!
Up, Up, Down, Down, Left, Right...WHAT?!?!
acrylic on canvas — 30 x 24 inches
inspiration: **Contra** (NES)

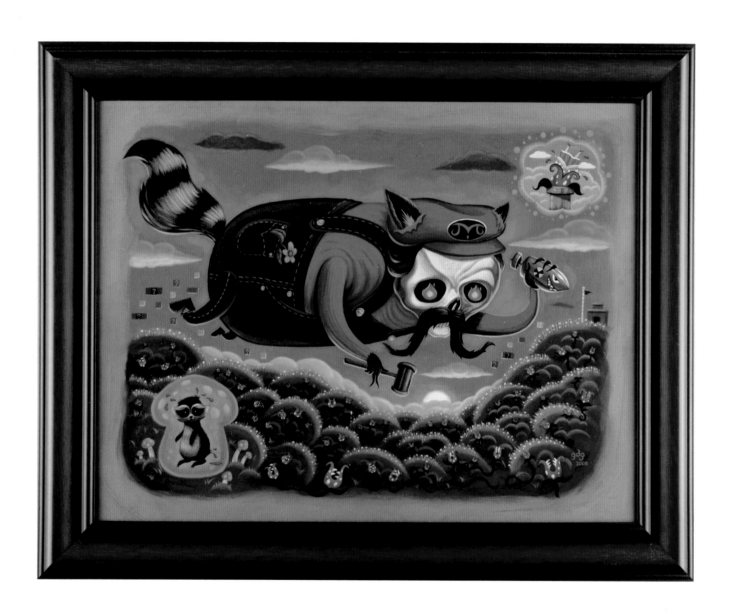

GERALD DE JESUS
Super Mario Armageddon
acrylic on masonite board — 24 x 18 inches
inspiration: **Super Mario Bros. 3** (NES)

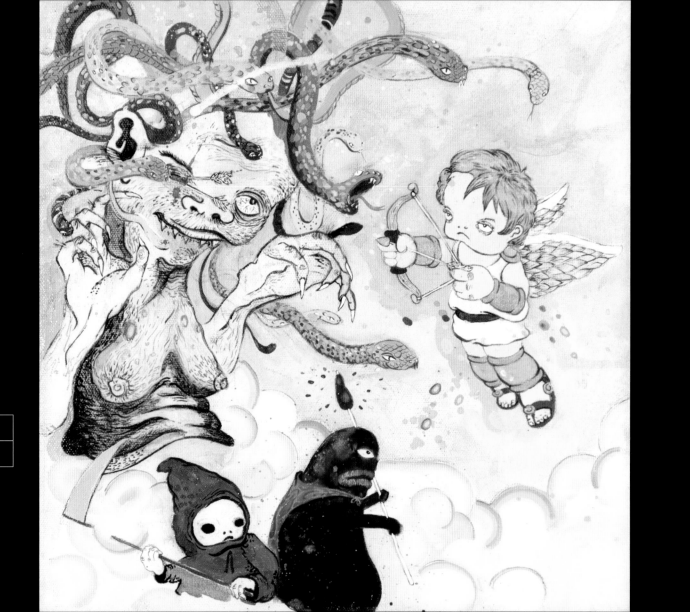

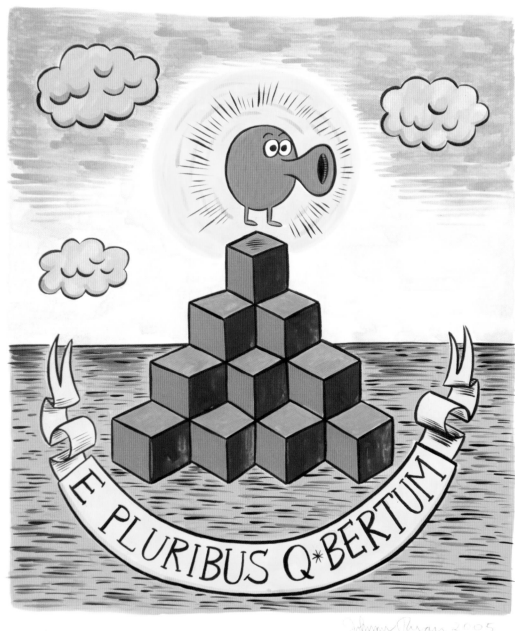

JOHNNY RYAN
E PLURIBUS Q*BERTUM
watercolor and ink on bristol board — 15½ x 15½ inches
inspiration: Q*bert (arcade)

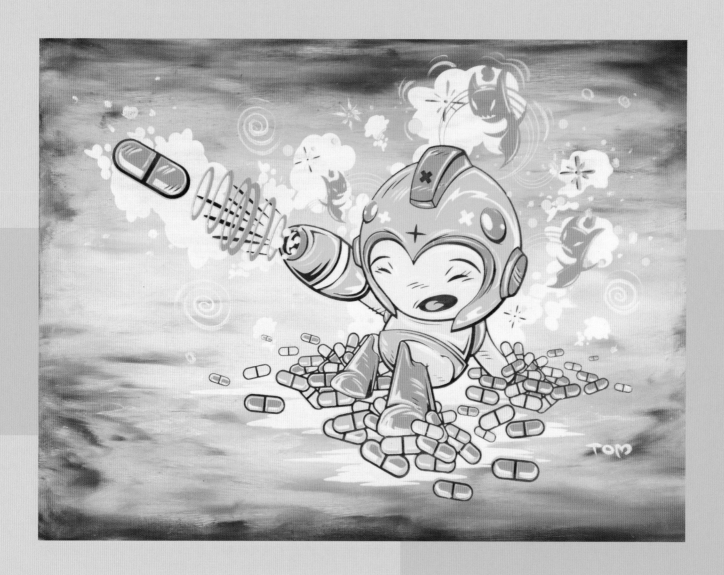

THOMAS HAN
Mega Lost
acrylic on wood — 12 x 9 inches
inspiration: **Mega Man** (NES)

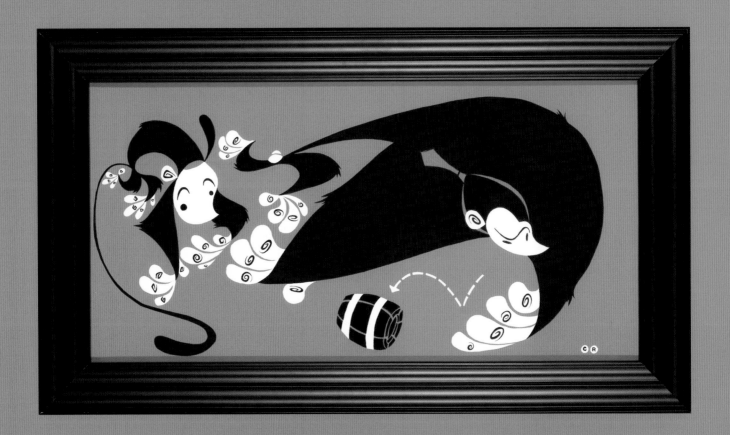

CARLOS RAMOS
Donkey N' Diddy
cel vinyl on posterboard — 23 x 13½ inches
inspiration: **Donkey Kong Jr.** (arcade)

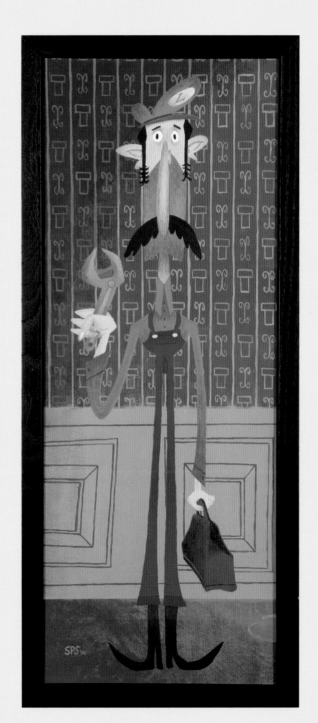

SEAN SZELES
Somebody Call A Plumber?
cel vinyl on illustration board — 9 x 21 inches
inspiration: **Super Mario Bros. series**

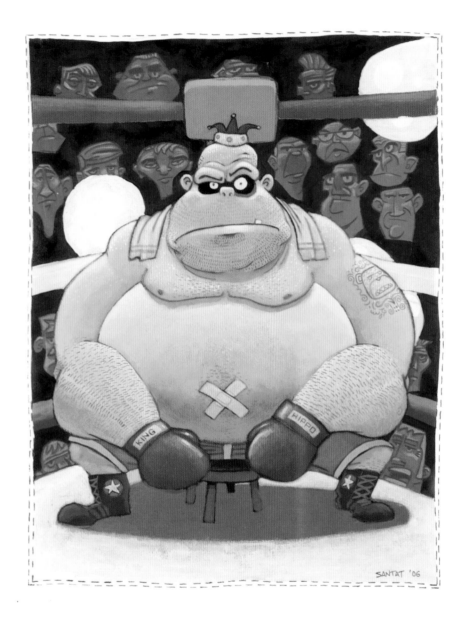

DAN SANTAT
All Hail King Hippo
acrylic on paper — 18¾ x 21¾ inches
inspiration: **Mike Tyson's Punch Out!!** (NES)

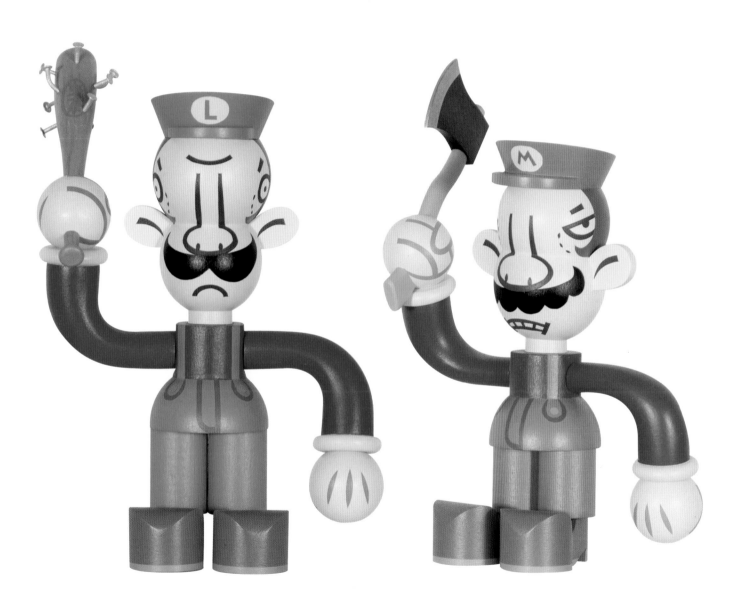

MIKE BURNETT
Luigi the Lunatic
acrylic and wood sculpture — 7 x 9 inches
inspiration: **Super Mario Bros. series**

MIKE BURNETT
Mario the Maniacal
acrylic and wood sculpture - 7 x 7 inches
inspiration: **Super Mario Bros. series**

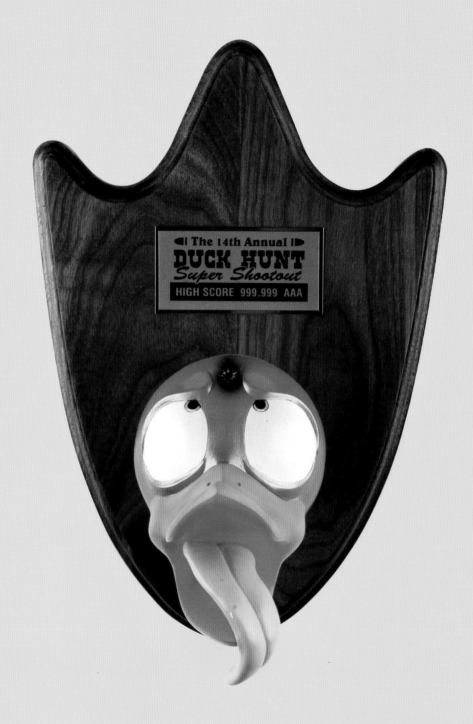

ERIC TAN

The 14th Annual Duck Hunt Super Shootout
resin and wood sculpt — 10½ x 14 x 10 inches
inspiration: **Duck Hunt** (NES)

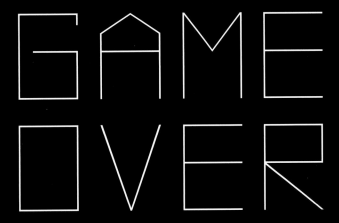

HIGH SCORES

JASON ADAM 126000

Jason sees things that aren't there... yet. A chipper fellow, he co-owns the design firm Hexanine, who styled up this very tome, and he awesomely chairs the Programming Committee for AIGA Los Angeles. He continually aspires to one day live the Bruce Wayne lifestyle. **JasdonLe.com**

AXIS 113000

London born, AXIS is an illustrator/painter who emerged from LA's seminal graffiti scene in the '80s. He is most noted for his convoluted, hyper-stylized freehand bombings, which have appeared on the streets of the world. Axis lives in LA where he paints, skates and plays music everyday. **StylePig.com**

GARY BASEMAN 91000

Gary blurs lines as a painter, illustrator, video & performance artist, animator, TV/movie producer, curator and toy creator. He designed the best-selling game, Cranium, and created the Emmy-winning show, *Teacher's Pet*. His art has been displayed in galleries and museums worldwide. **GaryBaseman.com**

SCOTT BELCASTRO 102000

Scott's artwork is a beautiful contrast between vast, dramatic skies and the meticulously detailed landscapes below, often expressing loneliness and hope. He currently lives in LA. **ScottBelcastro.blogspot.com**

CHRIS BISHOP 50000

Chris pays homage to his two true loves in his "Pretty Girls and Robots" series, exploring themes of beauty, violence, strength and vulnerability. He uses bold outlines, cartoon simplicity and color to bring to life the cold-hearted death machines... and those are just the girls! **ChrisBishop.com**

MARK BODNAR 89000, 122000

Mark grew up by the shores of the Great Lake Erie in Ohio. He moved to a haunted quarter of the state capitol and earned a BFA from the Columbus College of Art & Design in 2001. Since then, his artwork has been seen in gallery shows from New York to Los Angeles, as well as various international publications. Bodnar created cartoons for Cartoon Network and currently lives and paints in Los Angeles. **MarkBodnar.com**

BUFF MONSTER 31000

Buff Monster's creative endeavors began by putting up thousands of hand-silkscreened posters across Los Angeles and in far-away places, and he now works on fine art paintings, collectible toys and select design projects. His work has been shown in galleries worldwide, often accompanied by large installations. He works tirelessly day and night to spread happiness, joy and a love of pink. **BuffMonster.com**

JUDE BUFFUM 75000

A Philadelphia-based artist whose clients include *The New York Times*, Courtney Love, HBO and Scion, Jude has received awards from *Graphis*, *Communication Arts*, AIGA, *Print* and *American Illustration*. In addition, he has taught design and illustration classes at the Tyler School of Art and the University of the Arts. **JudeBuffum.com**

BEN BUTCHER 114000

Ben is the creative lead in consumer products at Pixar Animation Studios. He prefers to spend his free time with his wife, Leeanna, and their dog Waffle in Northern California. Working with all forms of paper and discovering new ways of bringing it to life is what keeps his creative juices flowing. **Mellowpad.blogspot.com**

SCOTT C — 32000, 39000

Scott Campbell (aka Scott C) loves painting pleasant little paintings for you. Some of his notable projects include the *GREAT SHOWDOWNS* series, *Double Fine Action Comics*, the children's book, *Zombie In Love* (Simon&Schuster), and the videogames *Psychonauts* and *Brutal Legend* (Double Fine Productions). Scott lives in New York City and is really enjoying it. **pyramidcar.com**

MARTIN CENDREDA — 20000, 76000

Martin is a cartoonist and animator. His comics and art have been published by Fantagraphics, Drawn & Quarterly and Giant Robot, among others. He lives in Los Angeles with his wife, their 2 children and a cat. **Mart-C.Blogspot.com**

ANNA CHAMBERS — 110000, 136000

Anna can make your dreams come true! In a vision of soft and cute, there is the plush creature which she so lovingly creates all by hand. Amazing — YES! Believe it! **AnnaChambers.com**

DEE CHAVEZ — 88000

Dee's paintings are a reflection of her love for woodworking, dark fun creatures and rich color. Her work usually consists of 50% whimsy, 40% weirdness and 10% sugar. She received her BFA from Cal Arts and has worked in the animation industry for over ten years. **DeeChavez.com**

DAVE CROSLAND — 70000

Dave (aka King Gum) is a Los Angeles-based illustrator whose stylized art is a harmonious collision of traditional aesthetics and modern sensibilities. Dave's clients have included MTV, Ride Snowboards, IDW Publishing, Walt Disney Animation, Oni Press and more. **DaveCrosland.com**

JUSTIN DEGARMO — 118000

Justin was born in 1979 and was raised on a steady diet of multi-colored breakfast cereals and 8-bit videogames. Occasionally, he still partakes in both. He also paints. **JustinDegarmo.com**

GERALD DE JESUS — 139000, 142000

Emmy-winner Gerald de Jesus currently works out of Los Angeles and is influenced by the garden gnomes in his condo complex to do unlawful things, such as not recycling. He is a compulsive liar... and really hates painting. **ArtOfGerald.com**

BOB DOB — 16000

Bob was born and raised in the once-lazy beach town of Hermosa Beach, Cali. After his childhood dream of becoming a pro baseball player was taken from him due to a battle with cancer, he gravitated towards music and art. Playing in a punk band for 10 years named Lunacy, the exposure to the music scene in LA has greatly influenced his art. **BobDob.com**

SETH FISHER — 80000

Seth is gone (1972 – 2006), but his influence lives on. He was working on the promotional poster for the 2006 iteration of iam8bit, but never completed it. What you see here is just one version, displayed in this book as a tribute to an artist who was always a standout in style and execution, from his breakout *Green Lantern: Willworld* (2001) to his introspective voyage through the streets of Japan in *Vertigo Pop! Tokyo* (2002). Batman, Spider-Man and Fantastic Four also graced his brief, yet impossibly impressive resume. Encounter the flora and fauna of Seth's imagination, where noses bloom, eggs fly, and the only limits are self-imposed. **FloweringNose.com**

JOSE EMROCA FLORES
45000, 92000

As often seems to be the case with concept designers, most of Jose's projects are under a shroud of competitive secrecy, but you can see a nice sampling of his personal & professional work — ranging from projects for videogame studios like High Moon and EA to more individual pursuits — at: **Emroca.com**

NATE FRIZZELL
28000

A recent graduate of Los Angeles' Otis College of Art and Design, Nate's work focuses on bold and colorful images of children at play — and in turmoil — creating intimate stories that mask his own feelings of immaturity. He recently sold out shows in Los Angeles, New York and the UK. **NateFrizzell.com**

MATT FURIE
125000

San Francisco-based Matt Furie uses colored pencils and draws a wide variety of characters. Think *Sesame Street* for adults... on acid. **MattFurie.com**

PETER GRONQUIST
35000

Growing up in a creative family led to obsessive art-making throughout Peter's childhood that continues today. He attended the School of Visual Arts, but finished his BFA at the San Francisco Art Institute in 2001. He now resides in Oakland, trying to paint every day. **PeterGronquist.com**

MAX GRUNDY
62000

Max has been a painter, illustrator and graphic designer for the majority of his life... and an art teacher for the last decade. Conceptually, his artwork is based in America's love affair with fear and its consequential phobias. Formally, he is interested in vintage poster design around WWII (sci-fi, B-movie, comic book covers and propaganda). **MaxGrundy.com**

JORGE R. GUTIERREZ
36000
[AKA SUPER-MACHO]

Born in a brothel in Mexico City and raised by coyotes in Tijuana, Jorge is a Mexploitation writer/director, painter and cartoonista. He received his BFA & MFA for Experimental Animation from CalArts, and is best known for creating (with his saucy muse Sandra Equihua) the multiple Emmy-winning Nickelodeon series, *El Tigre: The Adventures of Manny Rivera*. **Super-Macho.com**

REX HACKELBERG
119000

Rex is a cartoonist from Toronto. Recognized for his playful drawing style and unique sense of color, his work has been used in lots of film & commercial projects. **Rex-H.blogspot.com**

THOMAS HAN
145000

Taiwan-born Thomas was somehow accepted in the weird, evolving pop art world, dedicating his life to painting pills and absurdly cute creatures that boogie. **Thomas-Han.deviantart.com omorama.com**

JOHN HARVATINE IV
56000

Härv is the master of miniatures, the maestro of minuscule, the monarch of itsy-bitsy! He has created "wonderful stop-motions" with his unique cinematic style and punishing sense of humor for Disney, Nickelodeon and Warner Bros. He is also co-owner of the LA-based stop-motion house, Buddy System Studios. **BuddySystemStudios.com**

THORSTEN HASENKAMM
105000

Thorsten was born in Padeborn, Germany in 1975. Almost immediately from birth, he started to draw. Not long after (2004, to be exact), he began showing his work in galleries across the United States and Europe. **Hasenkamm.de**

DENNIS HAYES IV 107000

Dennis uses a variety of influences, such as quantum physics, industrial design, geometry, political science and nature to form multi-layered, visual commentaries on our character as a society. His anthropological views are expressed using found materials on resurfaced refuse. DennisHayesIV.com

TERI HENDRICH 73000

A Southern California native, Teri obtained her BFA with Distinction in Illustration from Art Center. Pulling inspiration from instruction manuals, public signage and everyday life, her art is a fascinating commentary on desire and the modern individual's struggle to connect with others. TeriHendrich.com

RYAN HESHKA 64000. 79000. 115000

Ryan was born in Manitoba, Canada. He began drawing at an early age, influenced by natural history and the visual language of old comics, pulps and animation. His work has been seen in major publications and on gallery walls worldwide. Currently, Ryan lives in Vancouver. RyanHeshka.com

STELLA IM HULTBERG 27000

Stella is was an industrial designer before serendipitously becoming an artist. When not drawing, she's often found on her bicycle... or playing the NY Times crossword puzzle. StellaImHultberg.com

KOFIE ONE 22000

Very active in the West LA graffiti scene since the mid-90s, Kofie One's mechanically detailed line-work, organically complex structures and heavy earth-tone palette develop into a multi-layered, architecturally inspired world that is a futuristic realm not subject to gravity. KeepDrafting.com

STEVE LAMBE 137000

Steve is a Canadian born artist known to most people by his nickname, "LAMBEY". He began his career as an animator and quickly realized he was horrible at it. Luckily, character design was a much better fit. He has worked for studios such as Nickelodeon, Disney Television and WB, and in 2010, won an Emmy for his work. SteveLambe.com

TRAVIS LAMPE 66000. 100000

Travis was born in a small town in Kansas that you've never heard of. During his youth, he saw an old-timey cartoon at the matinée (probably *Steamboat Willie*) after which, elbows completely lost their appeal. He works in Chicago, churning out ridiculous and often pathetically sad paintings and toys. TravisLampe.com

JESSE LEDOUX 40000

A former Sub Pop Records art director and Grammy nominee, Jesse LeDoux formed LeDouxville in 2004 to focus on his client-based and personal work. His work was included in the Cooper Hewitt Design Triennial (2007) and an installation at the University of Maryland (2008), and has been exhibited worldwide. He now lives/works in Seattle. Ledouxville.com

JIM MAHFOOD
[AKA FOOD ONE] 134000

Jim is a freelance artist working professionally in the fields of illustration, advertising, comic books, murals, fine art, animation, live art in nightclubs and custom body-painting. Highlights of his career include illustrating director Kevin Smith's *Clerks* comics, vislualzing an ad campaign for Colt 45 malt liquor, and illustrating/art directing reggae legend, Ziggy Marley's *MarijuanaMan* project. JimMahfood.com

MIKE MITCHELL 63000

While he himself is just a regular dude who enjoys beer and sushi, Mike Mitchell's art is anything but. Unicorns shitting rainbows, gumball-headed bigwigs and wizards with a penchant for pin-striped beaters — yeah, that's what he paints. And makes into t-shirts. And showcases in galleries across the universe. **SirMitchell.com**

TONY MORA 116000

Born and raised on the rough streets of Norwalk, Tony has worked his way from the deepest trenches of animation to soaring to its highest heights. He now resides comfortably somewhere between those two worlds making art for videogames. He also loves his wife Mandy and son, Xavier, very much! **TonyMora.blogspot.com**

YUTA ONODA 120000

Originally from Japan, Yuta is an illustrator based in Toronto. He has been shaping his art aesthetic through various forms of media, finding new avenues of expression. **YutaOnoda.com**

MARTIN ONTIVEROS 58000

Martin is a part-time wizard/warrior, full-time artist... occasional werewolf, die-hard headbanger, bowler, single father, loyal friend, lover and all around great guy living and breathing in the Pacific Northwest. **MartinHead.com**

NATHAN OTA 41000

For years, Nathan has been pursuing new worlds. He travels through dreamlands that hold fantasies and tragedies, landing him in the unlikeliest destination... the world inside the artist's own studio. Ota currently teaches at Otis College of Art and Design and Santa Monica City College. **NathanOta.com**

DANIEL PEACOCK 78000

Growing up, Daniel remembers his Grandpa as a fine artistic doodler who influenced him to create his own early pictures with pencils, crayons and later, dip his paint brushes into colorful pigments of plastic, egg and oil. To this day, he loves the smell of turpentine in the morning. However, his short term memory is shot to hell, and his orthodontist thinks this might be related. **DanielPeacock.com**

PLASTICGOD 109000

Working under the pysedonym Plasticgod, Los Angeles-based artist Doug Murphy has established himself as a relentless pop culture manipulator and multiples revisionist. His work is collected by a pleothera of tastemakers, from Robert Downey, Jr. to Robin Williams, and has been showcased around the world in galleries, magazines and museums. **Plasticgod.com**

STEVE PURCELL 46000

When he's not adopting hideous ventriloquist dummies, Steve has worked as a comic creator (Sam & Max), illustrator for classic games (*Monkey Island, Zak McKraken*), story artist at ILM and currently writer and co-director at Pixar. He lives in Northern California with one wife, one dog and two boys. **SpudvisionBlog.blogspot.com**

CARLOS RAMOS 123000. 132000. 146000

Carlos graduated from the California Institute of the Arts and has created numerous shows for Cartoon Network, Disney and Nickelodeon, including *The X's* and *Chalkzone*. Ramos' work has been exhibited in numerous galleries, including The Corey Helford Gallery, Copro Gallery, Gallery 1988 and La Luz De Jesus Gallery. He currently lives in the hills of Silverlake with his fiance Timony and Boston Terrier, Bucket. **theCarlosRamos.com**

REUBEN RUDE 106000

Emerging from a bad fall on a skate ramp teetering toward acrylic on some scavenged board cresting the Pacific, a spray paint catechism affixed to his interior cranial wall and a numbered assortment of brushes with an authoritarian media-mix, torn, glued and up to his waist in the Tao of ten thousand fatal strokes. **ReubenRude.com**

JOHNNY RYAN 144000

Johnny was born in Boston and grew up in shitty Plymouth, just a mile away from the Pilgrim Nuclear Power Plant. He now lives in Los Angeles with his wife. **JohnnyRyan.com**

CHRIS RYNIAK 30000

Chris is a painter and sculptor of all manner of critters and thingamajigs. He currently resides in Northern Ohio where he hones his skills as a world-class jerk. **ChrisRyniak.com**

DAN SANTAT
24000, 42000, 148000

Dan is a children's book author and illustrator. He is also the creator of the Disney animated series, *The Replacements*. He lives in Los Angeles. **DanTat.com**

KEVIN SCALZO 59000

Kevin is a New York-based fine artist whose work has been shown in galleries around the world. Known mainly for his use of layered color arrangements mixed with disturbing cartoon imagery, he has developed a devoted following. He lives and works near NYC with his wife and daughter. **KevinScalzo.com**

SCOTT SCHEIDLY 57000

Scott lives in Florida where he enjoys floundering about and painting pretty pictures... and still eats paste to reminisce. Some day he hopes not to be famous. **FlounderArt.com**

SEÑOR CHIPS 139000

Señor Chips began making "calacas" ("Day of the Dead" dioramas) in his early 20s because he was too poor to buy the authentic ones. Ironically, he sells the calacas he makes for more money than the ones he couldn't afford. **SenorChips.com**

SHAWNIMALS 82000

Shawnimals is a character design studio that believes in the power of unbridled, astonishing, ridiculous joy. They create designer toys, lifestyle accessories, videogames and anything that fosters companionship. Friendship can happen between you and just about anything. Even facial hair. **Shawnimals.com**

ERIK SIADOR 129000

I just quit my job at Nike to finally live my dream as a full-time artist. Hopefully I've given enough back to the world by the time you have read this (05/24/2011). "There are those who create what we see, I create what we don't." **ErikSiador.com**

GREG "CRAOLA" SIMKINS
26000, 48000, 95000

Greg is a LA-based artist who got his start with a box of crayons and an overactive imagination. Picking up a paint brush was the fuel for a life-long obsession of making art and creating worlds that has made him one of the most sought after painters of his generation. **ImScared.com**

AMY SOL 97000

Amy's paintings are like willfully obscure, abstract fables in which she pairs images that she likes with personal ideas about the characters she creates. This visual vocabulary is the backbone to Amy's unique brand of storytelling, which she refers to as "muted allegories". **AmySol.com**

NATHAN STAPLEY 67000. 98000

Nathan was born in California, attended the Academy of Art in San Francisco, and worked as concept artist for LucasArts and Double Fine Productions. He was a member of the comic "collective" *Hickee*, and has shown his paintings in galleries all over. Nathan hopes you are doing good. **NathanStapley.com**

JOPHEN STEIN 85000

Jophen is a graduate of the Laguna College of Art and Design. After establishing the "Snootson Family Showcase" in 2004, his distinictive style gained national recognition. Despite the minor set back of being banned from Iowa, Jophen continues the SFSC series from his studio in Pomona. **JophenStein.com**

STONE 112000

When Stone Larkin founded Fused Metals, his mission was to create kinetic, metal sculptures that reminded audiences of the frailty of their own existence. He lives and welds in LA. **Facebook.com/pages/FusedMetals-By-Stone/188710234506813**

GABE SWARR 55000. 77000

Gabe is a 16-year veteran of the animation industry who dabbles in painting and comics. He is currently a supervising director and producer at Nickelodeon, and finds time to produce his own, weekly cartoon/comic series (which celebrates the 8-bit era), *Life In The Analog Age.* **LifeInTheAnalogAge.com**

SEAN SZELES 147000

Sean is a writer & storyboard artist for television on such shows as *Regular Show* and *The Marvelous Misadventures of Flapjack*. Every once in a while, when he's not making music or petting his cat, he decides to sit down and paint something, hoping it will turn out awesome. **SeanSzeles.com**

ERIC TAN 150000

Eric is a designer and illustrator originally from San Diego, graduated from Art Center College of Design and has worked at Disney Consumer Products for over a decade. When not holding a stylus or pencil, Eric usually has either a burrito, a skateboard or a snowboard in hand. **EricTanArt.blogspot.com**

THE CHUNGII
124000. 130000. 140000.

Dave Chung (aka The Chungll) sees the world through cartoon eyes — colorful, exaggerated and in rapid action. He paints human experiences to the cue of awesome, culling inspiration from the sights and surreality of LA. **TheChung.com**

CAMERON TIEDE 25000

Raised in the great white north of Canada on sugar-infused cereal, 80's music and NES games, Cameron never grew up. He draws, paints and designs for himself and others, including Disney, Mattel, Nickelodeon and Warner Bros. His work is exhibited and collected around the world. **CameronTiede.com**

JEREMY TINDER 52000. 90000

Jeremy is a Chicago-based artist. He makes paintings, writes and draws comic books, designs toys and clothing. He exhibits his artwork internationally as a solo artist and with the artist collective Paintallica. **JeremyTinder.com**

ROLAND TOMAYO 19000, 84000

Roland's exploration of the gallery world began with the creation of *Battle For My Affection*, which was submitted for selection for the second annual iam8bit show. Roland is honored that this piece, which began his gallery career, is being recognized in this amazing book. **RolandTamayo.com**

HOWIE TSUI 143000

Howie is an Ottawa-based artist and musician born in Hong Kong. His series, *Horror Fables*, has been exhibited throughout Canada. His work has appeared in *Beautiful/Decay* and and is part of the Canada Council Art Bank collection. **HowieTsui.com**

RICH TUZON 18000, 103000

Rich attended the California State University of Long Beach as an illustration major to pursue his life long dream of becoming a Disney artist. That became a reality two days after graduation... and 16 years later, he can still be found wandering the hallways at the studio. **RichTuzon.blogspot.com**

AIYANA UDESEN 47000

Aiyana is a San Francisco-based artist who specializes in portraits of celebrities and small animals. She loves music from the 80s, vegetarian food, fancy cocktails, rats, plants, hair dye, soap operas and art openings. **Aiyanaville.com**

YOSUKE UENO 43000, 128000

Born in Japan, Yosuke started to create original characters early in childhood. Self-taught, he started exhibiting his pieces when he was 16, specializing in symbolism. The theme of Yosuke Ueno's art is "Love, Space and Positive Energy." Known as Spaceegg77, he lives in Tokyo. **SpaceEgg77.com**

RON VELASCO 68000

Ron loves character-centered illustrations, in which he conveys human emotions, thoughts and persona via a variety of mediums, from paint to digital. He has shown his work in Black Maria Gallery, Climate Gallery, La Luz de Jesus, iam8bit and ISM Art Community. **RonVelascoArt.com**

JOE VAUX 21000, 87000

Although Joe's influences and abilities have evolved, his imagery seems to grow out of adolescent sensibilities. Absurd environments and characters are the players in a demented adaptation of his life story. He hopes that within the madness, the viewer will find the comedy that is our existence. He lives in LA with his wife, kids and dog. **JoeVaux.com**

AMANDA VISELL 60000, 72000

Amanda's fine art career sprouted from continuing failure. A high school drop out and Cal Arts reject, she moved to LA to pursue a career in animation, eventually finding her way into the gallery scene. She's been exhibiting her paintings and sculptures internationally since 2005, **AmandaVisell.com**

YOSKAY YAMAMOTO 34000

Born and raised in Toba, Japan, Yoskay moved to the US at the age of 15. A self-trained illustrator, he nostalgically blends pop iconic characters from his new Western home with traditional and mythical Japanese elements. **Yoskay.com**

JOHNNY YANOK 51000, 101000

Johnny draws everything from adorable teddy bears to snot-filled zombies. He's made pictures for Disney, Target and Fisher Price, graduated from Columbus College of Art & Design and lives in Ohio with a cheeky, little pug dog. **JohnnyYanok.com**